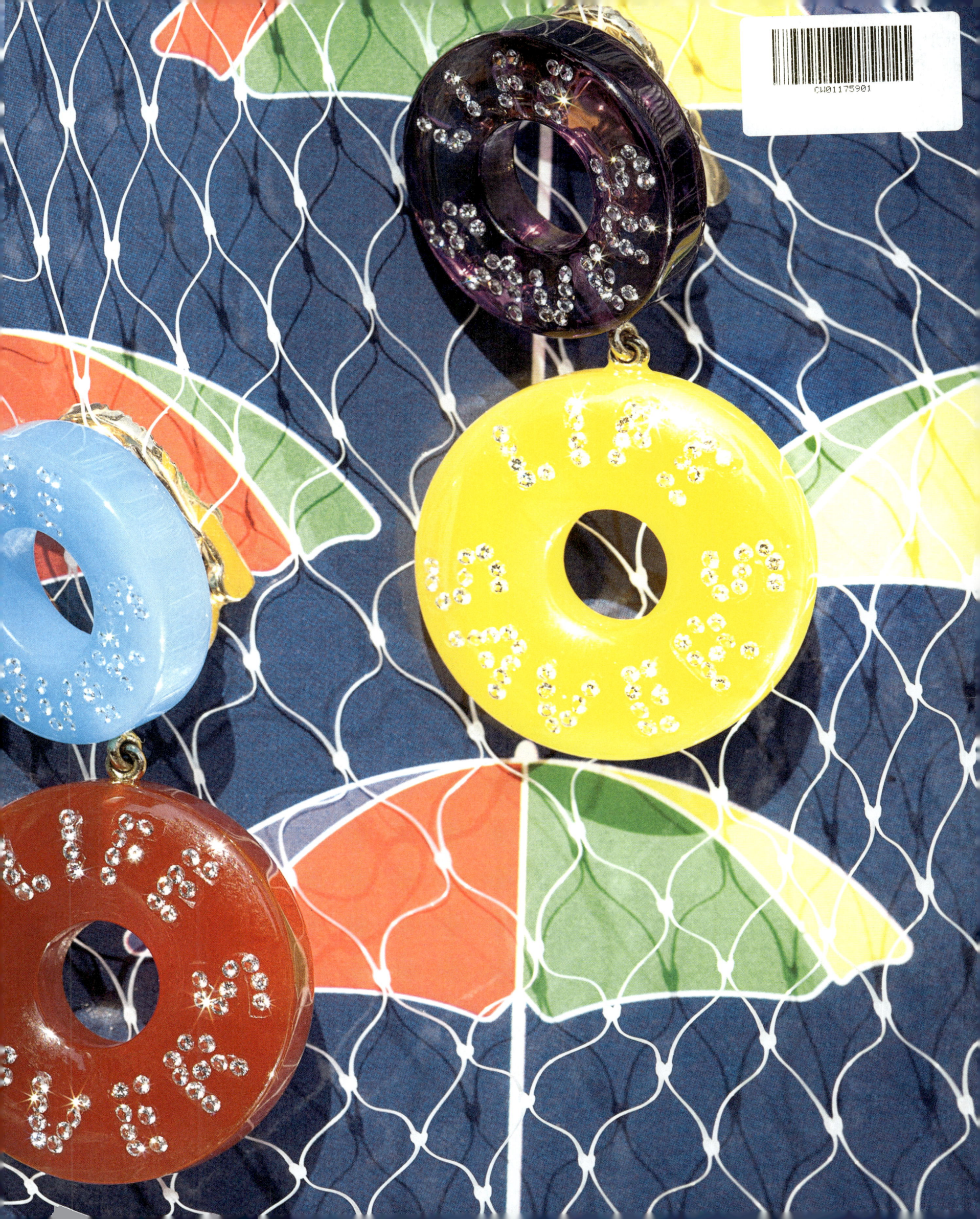

SUZANNE SYZ

ART JEWELS

Front cover: © Ezra Petronio.
Back cover: © Philippe Fragnère.
Slipcase: Both images © Philippe Fragnière.
End pages: © Roe Ethridge. Courtesy of Andrew Kreps
Gallery and Mai 36 Galerie.

© 2013 Assouline Publishing
601 West 26th Street, 18th floor
New York, NY 10001, USA
Tel.: 212-989-6769 Fax: 212-647-0005
www.assouline.com

ISBN: 9781614280873

Suzanne Syz Haute Joaillerie
13, rue Robert Céard
1204 Geneva, Switzerland
+41 (0)22-310-20-84
www.suzannesyz.com

Color separation by Luc Alexis Chasleries.
Printed by Grafiche Milani (Italy).

All rights reserved.
No part of this publication may be reproduced, stored in a retrieval system,
or transmitted in any form or by any means, electronic, mechanical,
photocopying, recording, or otherwise, without prior consent from the publisher.

SUZANNE SYZ

ART JEWELS

ASSOULINE

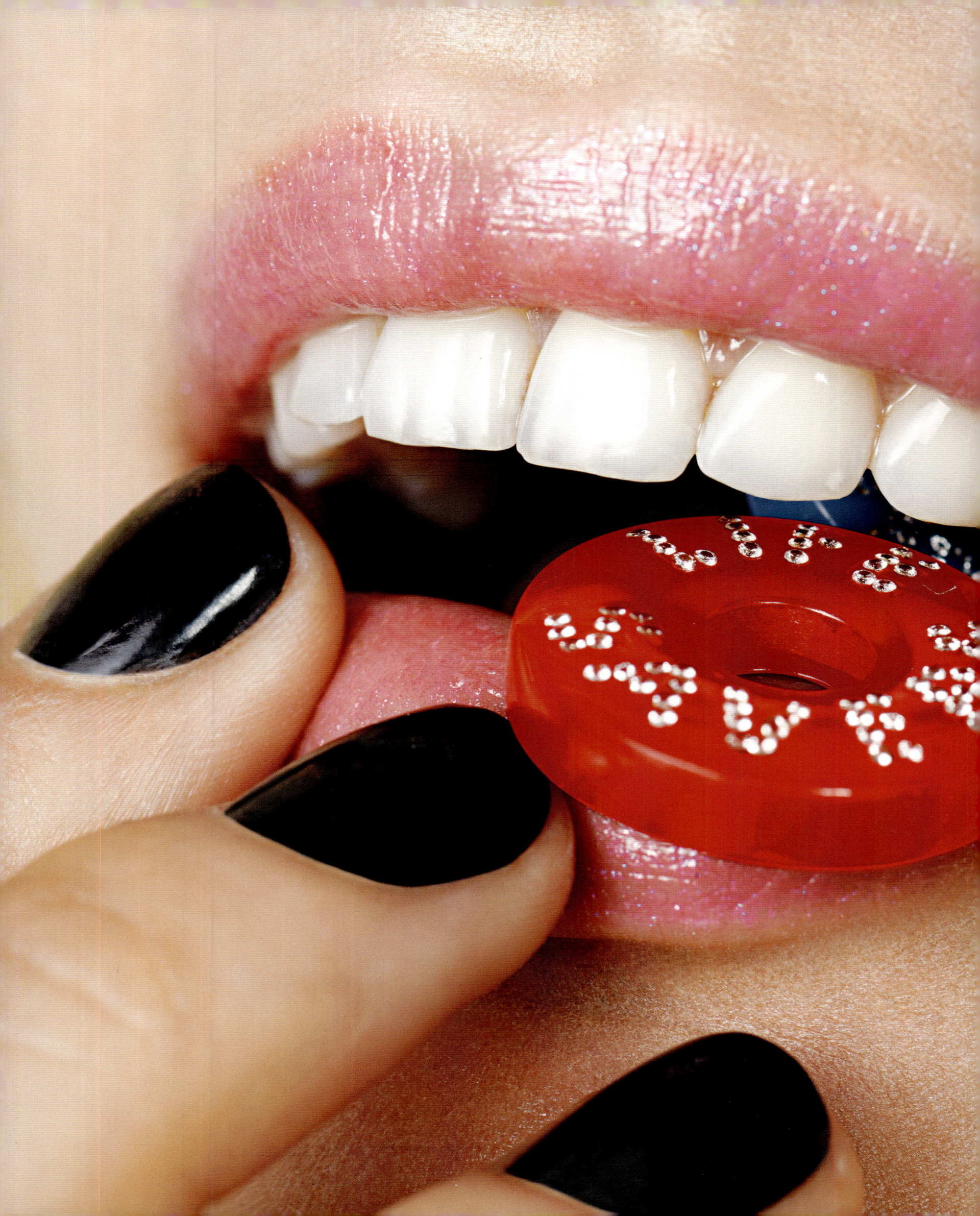

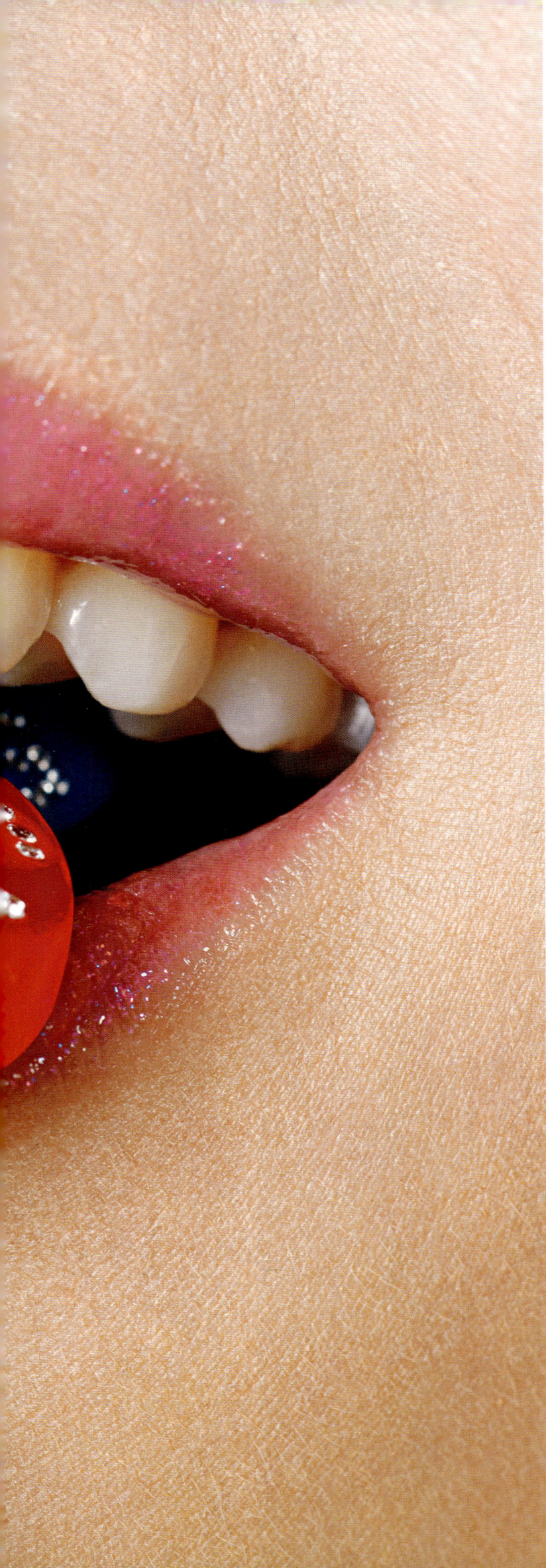

CONTENTS

Suzanne Syz Interview by Nicolas Trembley

6	Preface	148	Precious
8	Amour de l'Art	158	Queens
24	Boudoir	164	Rainbow
38	Contemporary	168	Suzanne
52	Dreams of Diamonds	170	Thank-You
58	Eclectic	172	Up-to-Date
72	Family	176	Views
76	Glamour	180	Wine
84	Happy/Humor	188	Xmas Cards
94	Inspiration	192	Year (10th Anniversary)
108	Joy	196	Zyz-Syz
110	Kaleidoscope	198	Jewelry Plates
118	Love (for Dogs)	200	Acknowledgments, Supplemental Art Information, and Credits
122	My Homes		
134	Nature		
142	Only You		

PREFACE

I began creating my own jewelry because I could never find what I wanted. I was looking for jewelry that was whimsical and funky, but the pieces I found were serious and dull—not playful, and the stones were just showing off their carats! I wished for something more understated and fun. I wanted to take the seriousness out of jewelry while using the best quality of stones. My first piece was *The Frog*, the famous "kiss the frog" ring: a little frog sitting inside a large crown with a prince charming inspired by Grimm's fairy tale. It was the first of a thirty-piece collection completed after four years of work, research, and technical training. I have actually been making jewelry for fifteen years, but only showing my work for the past ten. It took five years to perfect my craft; accumulate stones; find the best workshops; and learn the different aspects of the jewelry business. That's the perfectionist in me! Before *The Frog*, I made a pair of earrings for myself called *The Sun and the Moon*. They were immediately featured in *W* magazine. From the very beginning, I decided to only create one-of-a-kind pieces that are fanciful, youthful, and timeless. I had found my style. Today, women don't want "in your face" jewelry: They want unique, original designs of the highest quality. And I like to make pieces that defy the ordinary, otherwise it's no fun. I want my creations to be outstanding and witty—that's my signature. The *Life Savers*, *Smileys*, and *Smarties* reflect that attitude as well as the influence of pop art. But creative freedom stipulates impeccable technical expertise and the finest materials. Clients are demanding and expect the best. Each piece of jewelry must be crafted to perfection. My jewelry is only produced in Switzerland and the "Made in Switzerland" label is very important. I visited many ateliers and it was only in Geneva that I found the savoir-faire and level of craftsmanship I was seeking. The Swiss's extraordinary expertise with settings is related to the art of watchmaking; no other country can match their standards of exacting precision. The masters of these ateliers are true artists. When I started out, some people's reactions were patronizing—as if I were just a banker's wife dabbling with a hobby. It took some time for individuals in the field to understand that I took my work very seriously. Now, my greatest reward is when artisans tell me: "We are so proud to work for you because it's always a challenge."

Amour de l'Art

When did you first become interested in art? Did you grow up in a family that emphasized culture?

I grew up in a rather interesting environment; my father painted watercolors, mostly landscapes, places, people, and marketplaces because he spent a lot of time in the south of France and in Italy. He was a gifted painter and passionate about it, but he did it for himself, not professionally, even though his work was eventually exhibited. My mother did fashion sketches. My father also owned modern art. He liked the Impressionists but collected modern works—I especially remember Braque. He was a lawyer in Zurich, a jazz musician, and ran an independent film house while my mother oversaw the affiliated restaurant. My mother was very young when she married my father. She was an actress at the Schauspielhaus in Zurich.

Did your parents take you to museums?

My mom used to take us to the Kunsthaus in Zurich, our hometown. When we traveled, we would go to museums, sometimes too many museums [laughter]! We visited the Loire castles and took similar cultural trips. I grew up in a classically-oriented culture, but my mother was a woman of the times: Papa commissioned portraits of her by some of the more or less local painters of the 1950s and '60s. One of them was pretty good, done in a modern style.

What was your schooling experience?

I first went to a school in Zurich before going to a boarding school in Lausanne, where I received my high school diploma. I then left for Paris.

Tell me about that time…

I decided to go to university there, but that didn't last very long [laughter].

What did you study?

I studied literature and wanted to later earn an interpretation degree. My father said that I had to do it in German-speaking Switzerland, but I didn't feel like returning. I didn't want to be dependent any longer. I had a cute little apartment that I shared with a friend; she modeled at fashion shows and asked me if I felt like doing it.

As a young woman in Paris, were you involved in the arts?

Yes, I visited museums but mostly, even back then, I went to flea markets. I bought knick-knacks, inexpensive furniture, and a few paintings for the apartment. And that's probably when I began collecting.

At that same time, you were a runway model and involved in the world of fashion: Were you in contact with fashion photographers? Were you interested in their work?

Yes, when I began working with photographers, I realized very quickly that Guy Bourdin was the father of contemporary fashion photography, the most important photographer of that time. For me, he's really the one who influenced Helmut Newton or Steven Meisel. They all recognized his importance. I thought his photographs were simply brilliant. He did those famous ad campaigns for Charles Jourdan. In the 1970s I was lucky enough to meet him: We worked on some shoots together, when I was a beginner and inexperienced. He was a great artist who destroyed most of his work before he died.

Since then, you have put together a small ensemble of fashion-related images within your huge collection of photographs. Was this choice related to your personal history? Or because you think fashion photography is on the same level as fine art photography?

Fashion photography is on another level than fine art photography, but my choice was definitely tied to my fashion-related history. Guy Bourdin was a precursor to what is happening today in fashion photography. We also own some great older photographs of Helmut Newton and Steven Meisel, but the number is relatively small compared to our more important collection of fine art photography.

Do you see a difference, a hierarchy between fashion photography and fine art photography?

Well, I believe that in the field of fashion photography there are people who simply take pretty photographs that don't necessarily translate into art. Fine art photography implies a different level of research, a different background.

Do you have any other specific memories of that time that are connected to art?

I still have a painting—not a photograph—that I bought in Paris: a portrait of a woman that's typical of the 1920s and art deco, someone unknown. I thought it was absolutely beautiful and it was probably the first piece of art I bought.

John Armleder, *Antennaria Dioica*, 2008. Mixed media with glitter on canvas, 118 x 79 inches (300 x 200 cm).

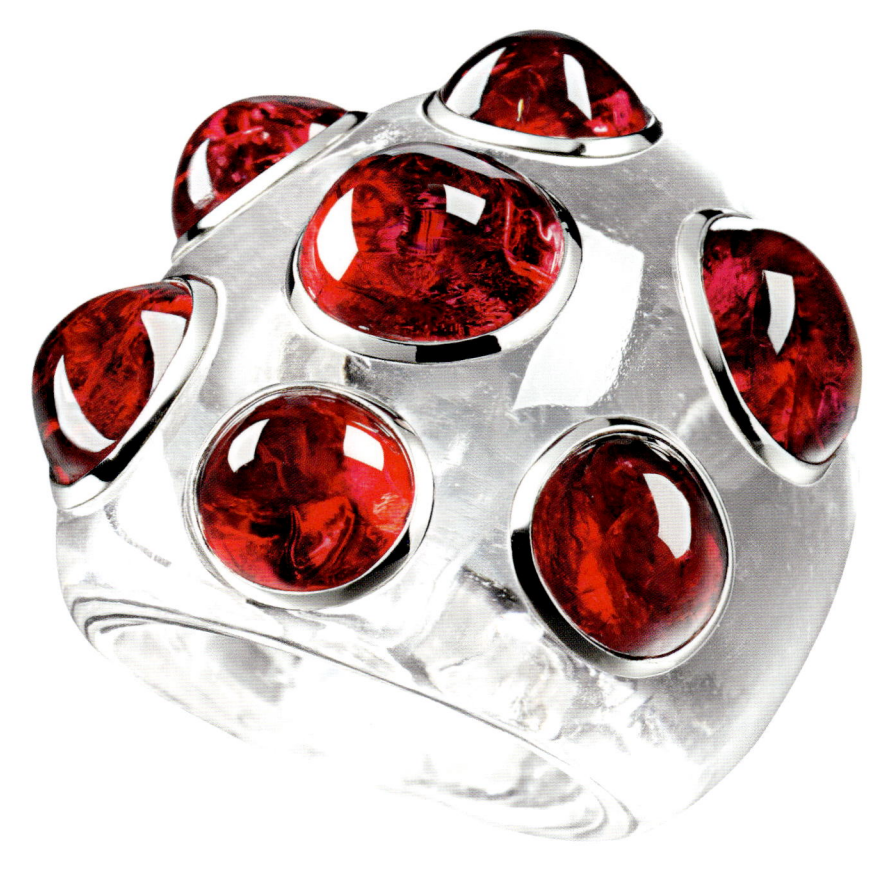

"AN ARTIST IS SOMEBODY WHO PRODUCES THINGS THAT PEOPLE DON'T NEED TO HAVE."

ANDY WARHOL

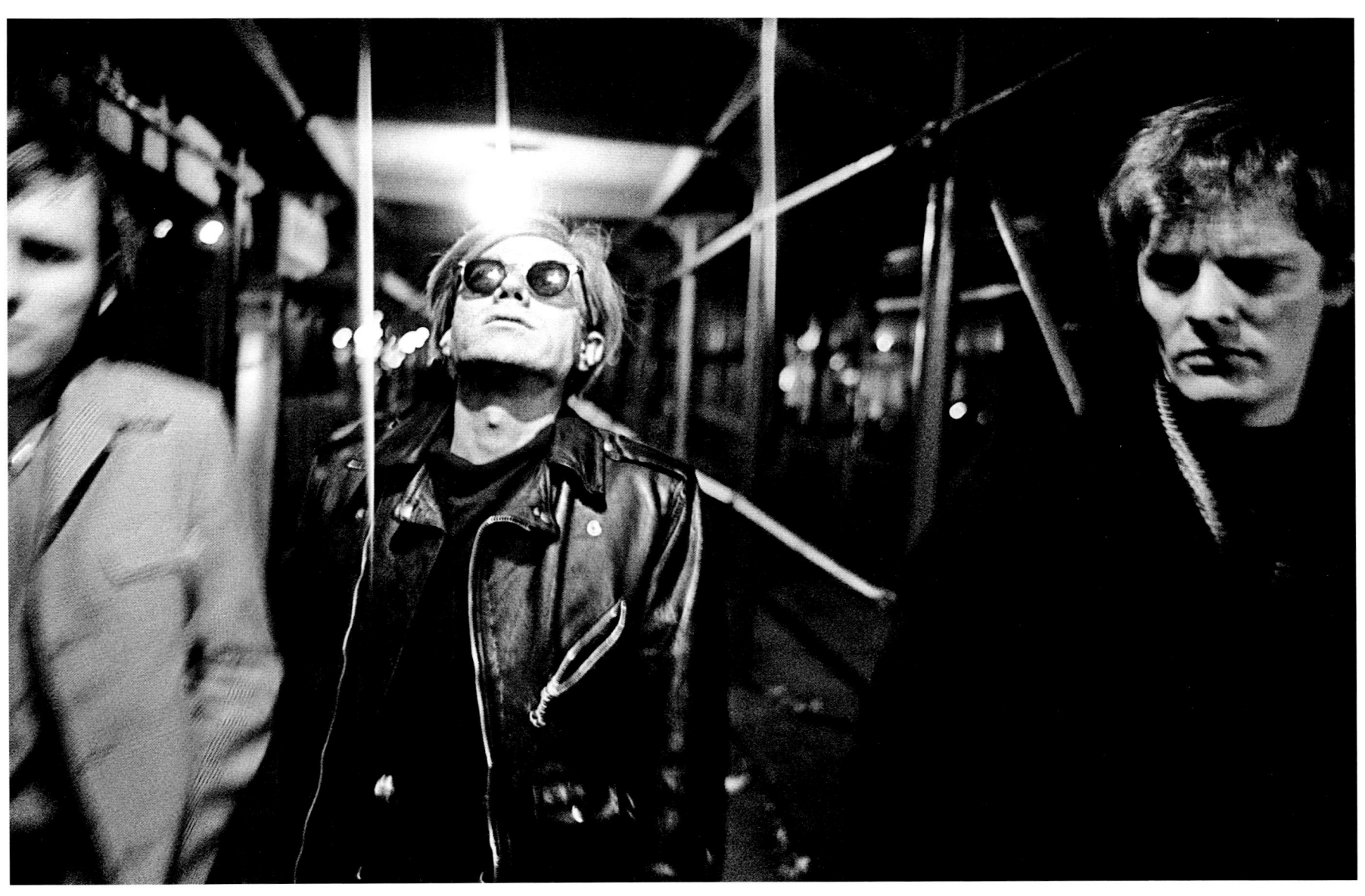

Stephen Shore, *Rod Elrod, Andy Warhol, and Paul Morrissey*, 1965–1967. Black and white photograph, 12.8 x 19 inches (32.4 x 48.3 cm).

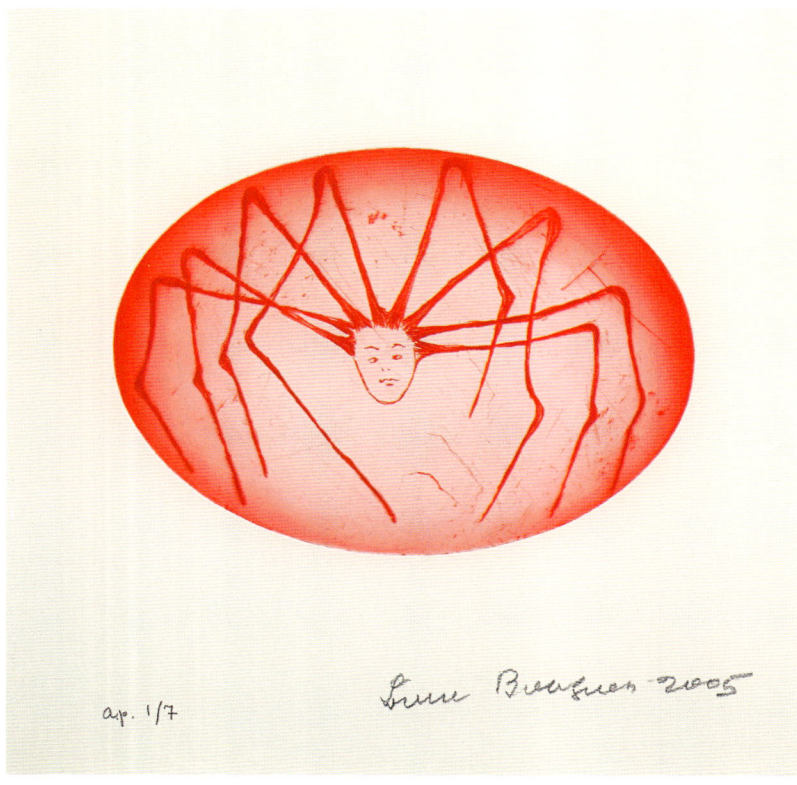

You moved to New York with your husband in the 1980s. It was an extremely prolific time for art and it was when you began actively collecting art.

We were young, in our early twenties. We threw ourselves into the rhythm of that exciting city! When we arrived, we knew a Swiss gallery owner and friend, Bruno Bischofberger, whom we had met in the Engadine in Switzerland. He introduced us to many people, galleries, and artists, which helped us become connected to that era's exciting art world.

Bruno Bischofberger was very active then in New York, Zurich, and St. Moritz. He represented a large part of the New York art scene of the time, like Julian Schnabel, Jean-Michel Basquiat, George Condo, David Salle, and, of course, Andy Warhol—all artists that you have collected.

Bruno Bischofberger owned a house near St. Moritz and we did too. He set up a small studio next to his home where artists could stay during the winter. He invited us to one of his evening get-togethers. It was fascinating: Jean Tinguely, Julian Schnabel, and Francesco Clemente were there. There were always lots of people and that's how we met many artists. When we arrived in New York we saw them all again and Bruno introduced us to Andy Warhol.

It was the heyday of Soho!

Yes, everything was happening in Soho and we had a lot of friends there. Many artists who lived there had no money; sometimes we would buy something from them because their art wasn't expensive at the time—under $1,000. It was all very social, very friendly, and we were learning how to look at art. Annina Nosei's gallery was right next to the Milliken Gallery; she was a friend of ours. One day I walked in and she was getting something ready in the basement: It was Jean-Michel Basquiat's first show! I remember thinking that it was very powerful and new! I saw his *Indian Heads*; there were ten or twelve of them. I came home all excited and told my husband, Eric, 'Listen, I just saw a brilliant show, we should buy a piece!' But he thought they were too expensive—I remember it as if it were yesterday! So, we didn't buy then, but at his next show the price had already doubled! I wanted those paintings so badly I even asked my grandmother to lend me some money [laughter].

Above: Louise Bourgeois, *Spider Woman*, 2005. Drypoint on handmade paper, 13.5 x 13.5 inches (34.3 x 34.3 cm). Art: © Louise Bourgeois Trust/Licensed by VAGA, New York, NY. *Following page:* Barbara Kruger, *Untitled* (*Man's Best Friend*), 1987. Photographic silkscreen on vinyl, 95 x 113 inches (242 x 287 cm).

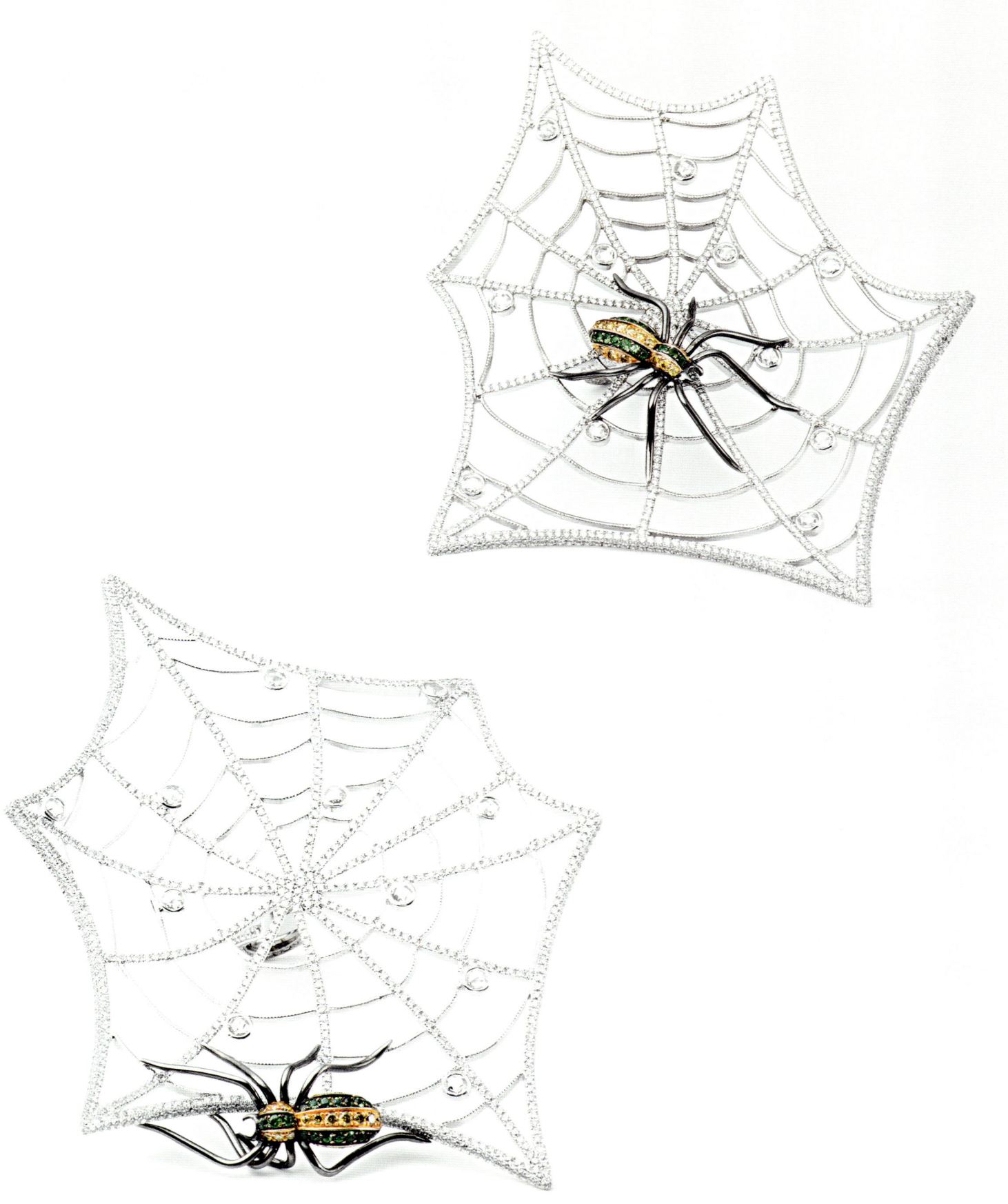

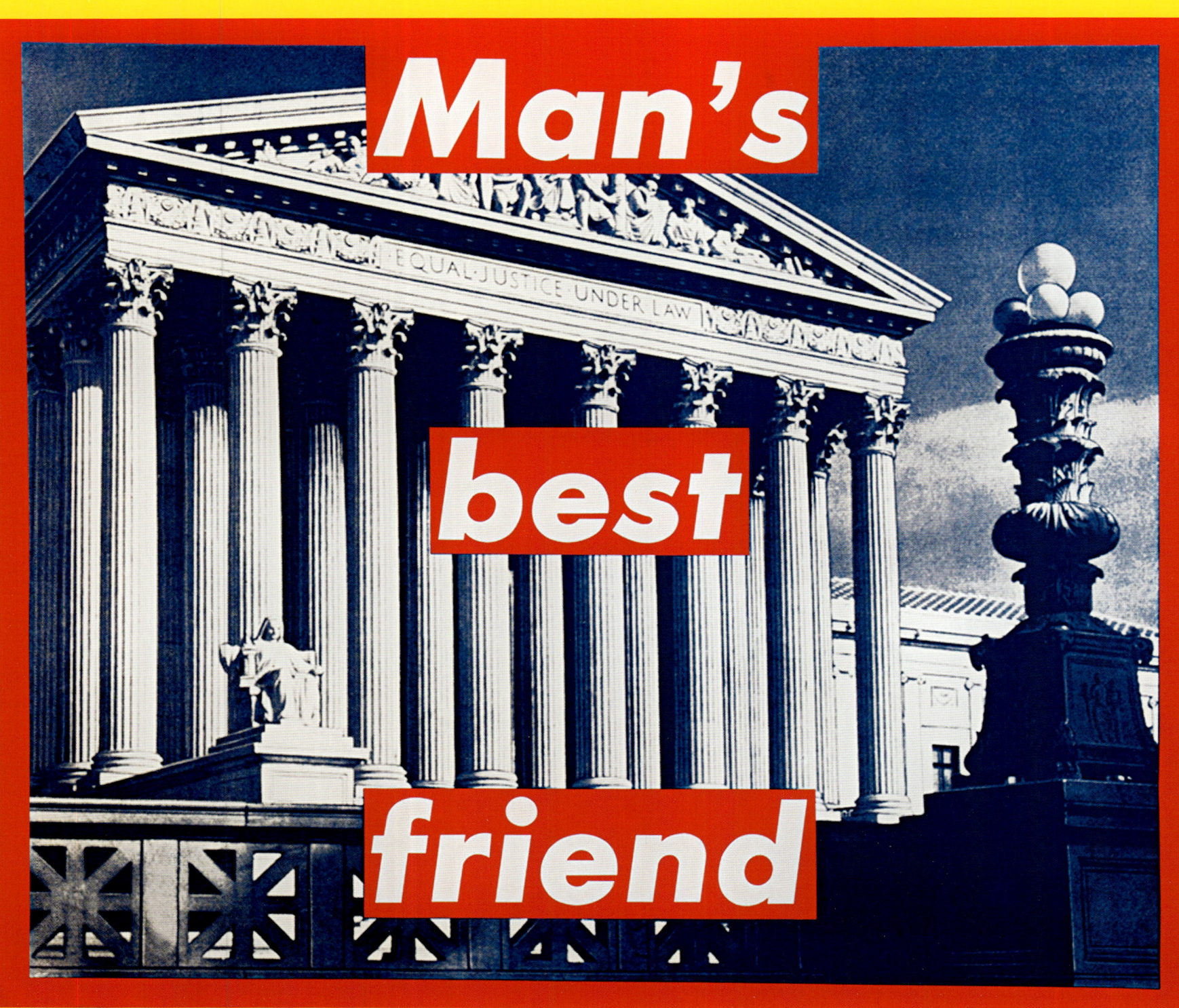

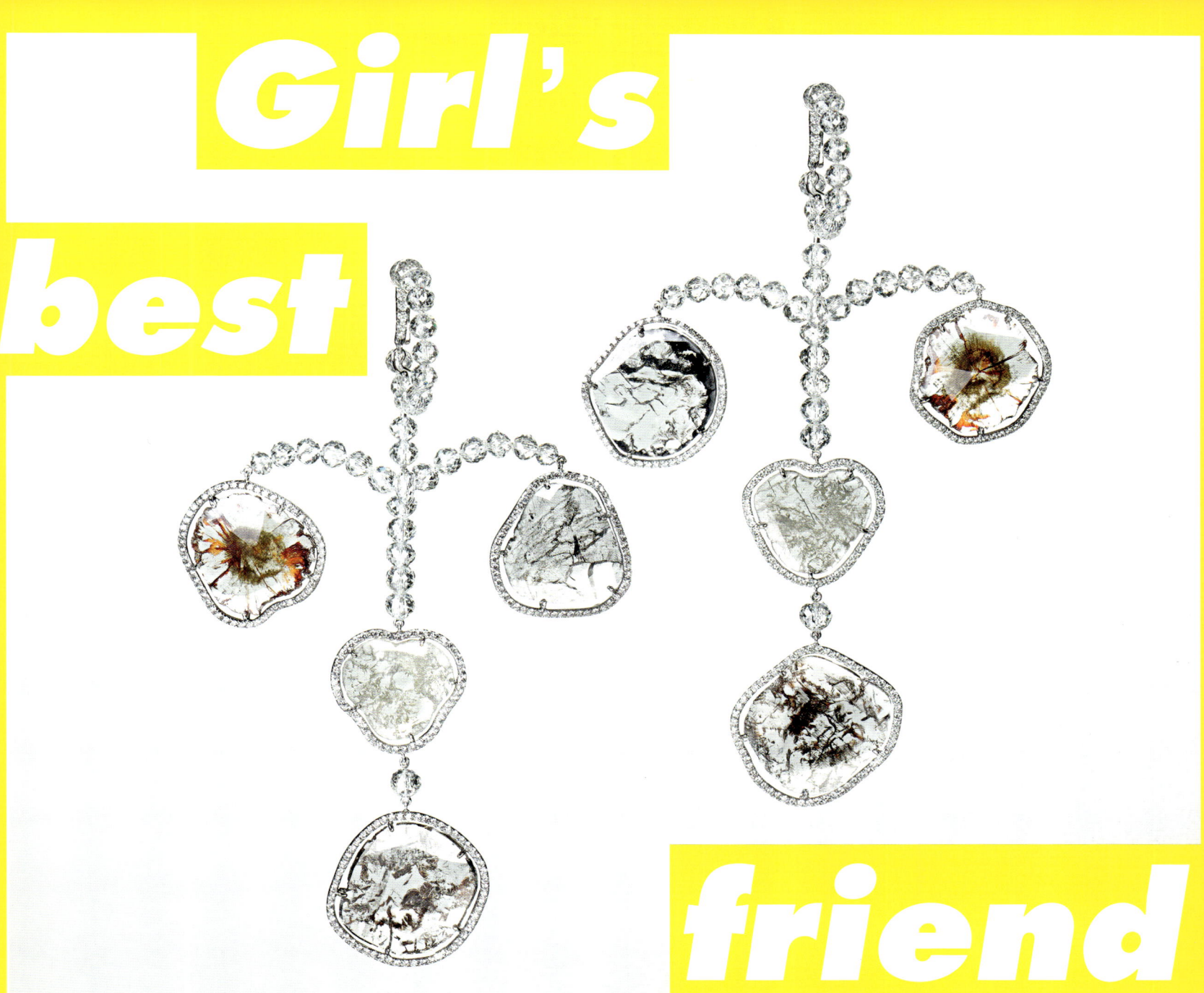

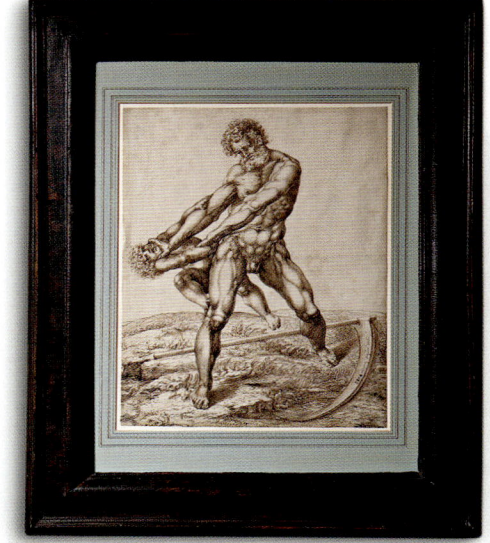
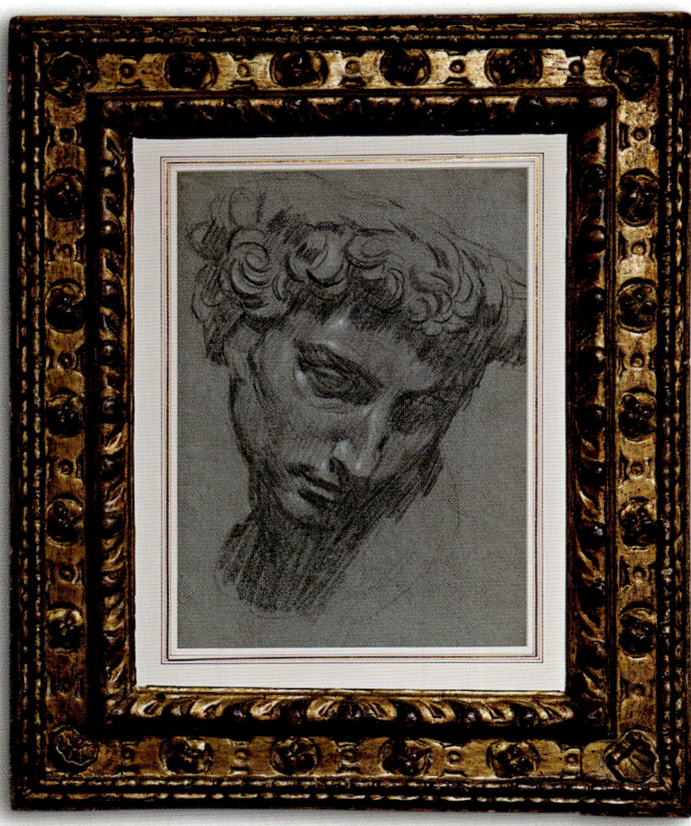
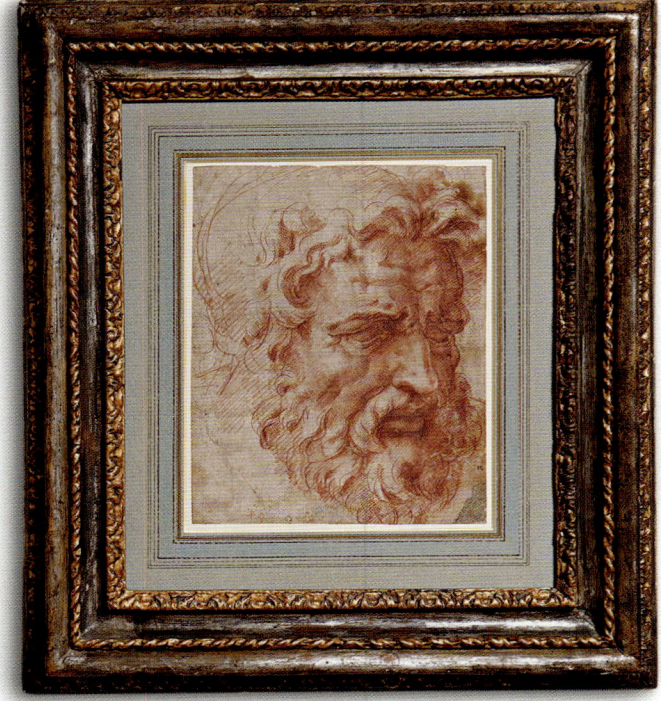

Did you meet Basquiat?

Yes, eventually, because Bruno Bischofberger regularly visited New York and would have dinner with Warhol and Basquiat since they were his artists. Actually, we got to know him better in St. Moritz, where he spent the winter in a hotel. I liked Jean-Michel and loved his paintings. One day, we were having dinner with him in a trendy New York restaurant, a brasserie on Broadway in the theater district. That evening he told us that he'd tried repeatedly to get into this restaurant when he was starting out, and that he could never get a table. How things had changed! He became the king of New York. He was the 'in' bad boy [laughter].

Did you think at that time that you were going to start collecting?

Yes, we had decided to collect artists who we knew and liked. We knew Julian Schnabel very well. He did a portrait of me that still hangs in my bedroom; Francesco Clemente did one of Eric; and McDermott McGough did one of the family. But I also liked David Salle and George Condo. We bought several of their pieces. David was really a sweetheart, like Georges Condo. Schnabel already had several assistants working in his studio. Everything ran so efficiently—things were perfectly organized and choreographed for visitors, almost like a play. At the time, he was already considered one of the most famous artists in New York!

Clockwise from left: Francesco Salviati, *Head of Hercules after the Antiques*, sixteenth century. Red chalk on paper, 10.2 x 8.3 inches (25.8 x 21 cm); Jacques Quesnel, *Time Killing Youth*, 1588. Black chalk, pen, and brown ink, 19.3 x 15 inches. (49 x 38 cm); Jacopo Tintoretto, *Portrait of Giulio Medici after Michelangelo*, sixteenth century. Black chalk on blue paper, 15.4 x 11 inches (39 x 28 cm); Camillo Procaccini, *Screaming Man*, Bologna, 1551; Milan, 1629. Red and black chalk, 6.2 x 4.2 inches (15.8 x 10.7 cm).

But you also amassed a small collection of 'master drawings'?
Yes, but they were very specific and tied to a particular period, between 1500–1700. When I was in New York, I was living in a very contemporary milieu, but I really enjoyed the company of an old friend who has sadly since passed away. His name was Charles Ryskamp and he was the former director of the Morgan Library and Frick Collection. We were very close friends and he taught me all about old master drawings. Looking back, I believe that if I had had the money, that I would have budgeted as much for old master drawings as I did for contemporary art. But we had to choose, and my husband and I chose contemporary art over drawings. What I like about drawings is the sense of spontaneity that a painting will never have. You can't do it over, like with watercolors (Clemente's, for example), and you can't start again. I learned that from my father, who painted watercolors. He used to say, 'On a good day, it's easy and I do it or I leave it alone.'

What attracts you to that period?
It was a very powerful period, and I wasn't interested in pretty portraits of women. I wanted to see strength—men with beards, like in Strozzi or Salviati, or even images that could be a little frightening, like Procaccini's *Screaming Man*, or Battista's anatomical drawings. I also adore Jacques Quesnel's *Time Killing Youth*, a sixteenth-century work depicting an old man fighting with a younger man. This French drawing certainly isn't something pleasant to look at, but clearly evokes a feeling of strength and is beautifully executed.

When your husband founded his company in Switzerland, you mainly acquired photographs. How did you come to that decision?
When Eric and his partners founded their bank, we talked a lot about whether we should exhibit pieces from our own collection. I thought it was a little pretentious for a new bank to own paintings, so I suggested something different and lighter. Photography had become as much an art form as sculpture, and I was especially interested in it within this particular context. Initially, I turned to Kaspar Fleischmann in Zurich for advice because he was a specialist in historical photography. The first photograph I bought my husband was a portrait of Giacometti by Man Ray.

You then added contemporary artists to your collection: Fischli and Weiss, Roman Signer…
At first, we wanted to only collect Swiss artists and Swiss photographs. But we quickly realized that adopting so narrow a focus wouldn't make a good collection. So we bought Barbara Kruger and Rosemarie Trockel works from Monika Sprüth, for example, and even younger artists like Wolfgang Tillmans from Hauser & Wirth. When we moved, I discovered a forgotten warehouse space in New York where we stored artworks. It was time to organize everything in a more professional way. We had gone from amateurs to more serious collectors, both in matters of logistics as well as in the selections we were making. Then came a moment when photography was everywhere and not all of it was worthwhile. I wasn't planning on delving any deeper into the enormous amount of photography being produced. It was becoming too difficult to sort through it all, too *fashionable*.

What does collecting mean for you?

It's really a passion and an excitement to discover new artists. For over twenty years I've loved attending fairs like Art Basel or the Venice Biennale. The art market has always shown artists' moods, and acts as a reflection of the times we live in.

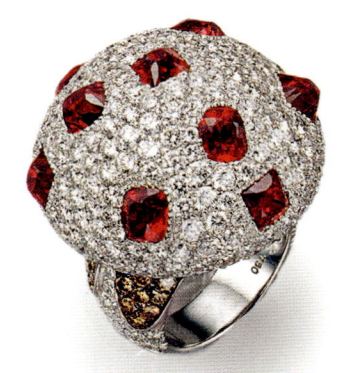

With the exception of a few pieces, your collection begins with works from the 1980s. Why is that?

That's simple; I believe that it's important to live in the present, so we buy artworks that are being created now. It's lovely to live with furniture and objects from the past, but I think it's important to embrace contemporary artists that represent what's happening now. That's what's interesting.

Is there a piece that you regret not buying?

Oh yes! If I had had the means, I would have loved to buy Warhol's *Car Crash Painting* from the Jablonka gallery. I would have spent my last penny for it. Instead, I bought the small *Frauen* sculptures by Thomas Schütte and I don't regret it; they are little treasures!

What is your collection's leitmotiv?

I think it will always be a commitment to young, gifted artists. I believe that a collection must grow through them. It's the idea of 'Let's capture the feeling of what's happening right now.' That said, we did buy works by Elaine Sturtevant because she is an essential link in understanding today's world and—like Rosemarie Trockel and Fischli and Weiss—she is a standard for future generations.

What differences do you see between the new generations of artists such as Wade Guyton, Kelley Walker, Roe Ethridge, and those who you knew in New York?

They are a continuation of the past, but they interpret the present in their own way and have their own ideas. They're all very talented. Andy Warhol was the precursor of everything related to pop art, and of every facet of contemporary art in many different fields.

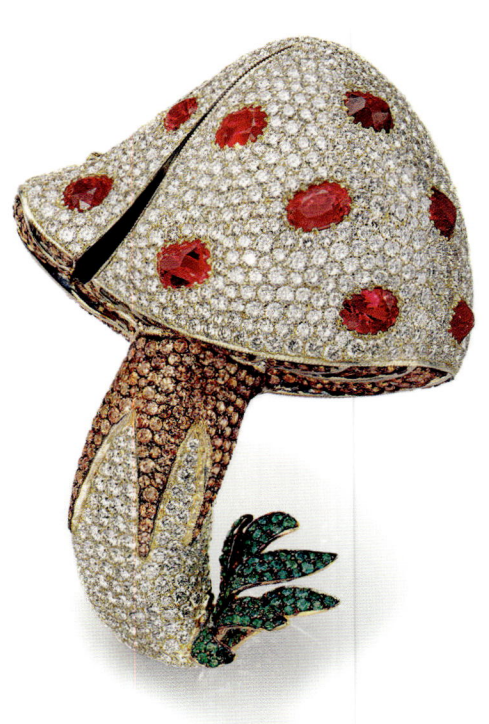

How do you see the future of your collection?

I would like to put on summertime shows at my *'fattoria'* in Italy, near Florence, to share the joy of these artworks with people. A collection is a constant work in progress and never finished.

In one word, how could you sum up your relationship to art?

It's my passion.

Carsten Höller, *Giant Triple Mushroom* (*Amanita muscaria/Coprinus comatus/Agaricus campestris*), 2010. Styrofoam, polyester paint, polyester resin, acrylic paint, core wire, surfacer, polyurethane foam, hard foam construction panels, steel, 102.4 inches high (260 cm).

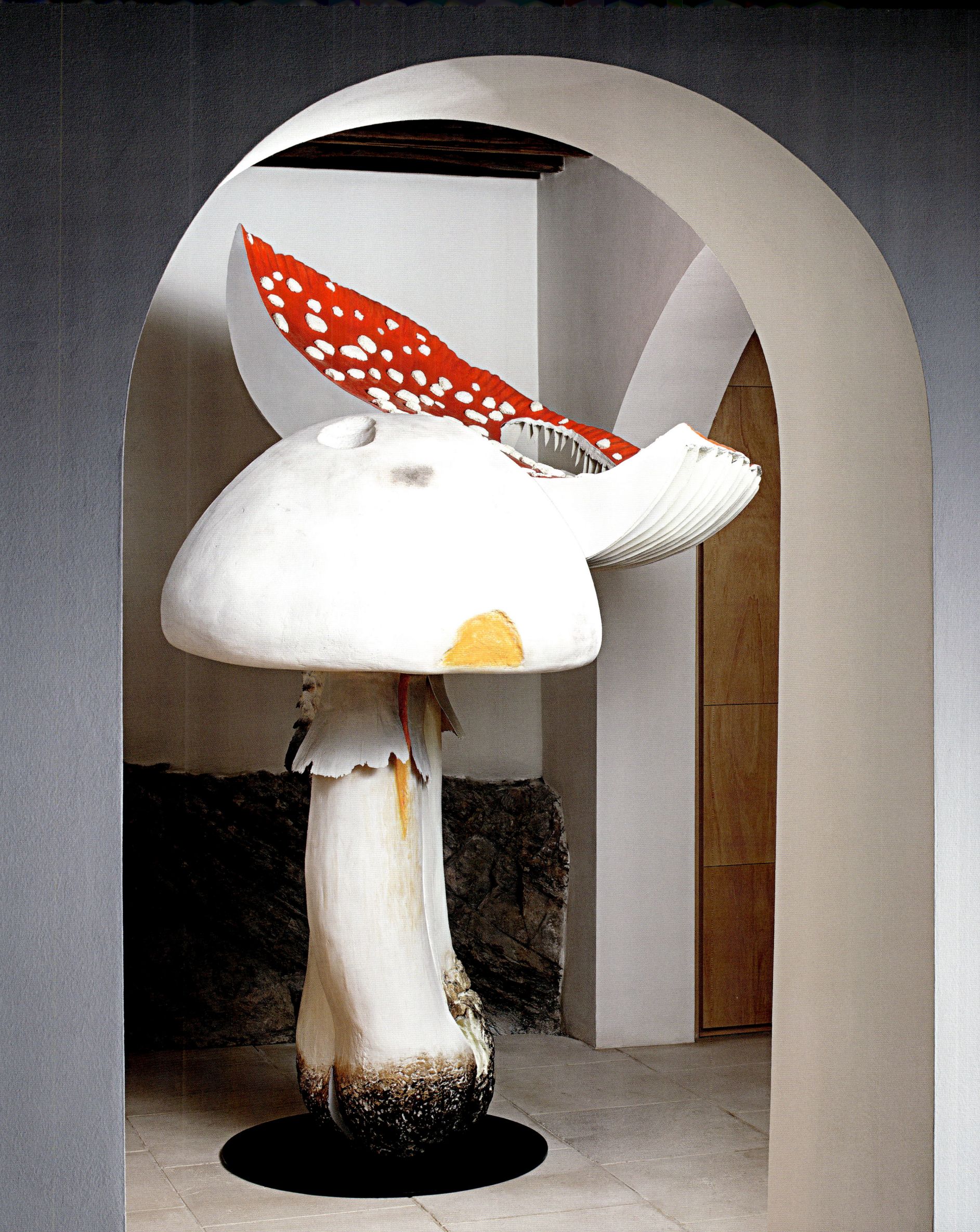

"I ALWAYS FELT THAT IT'S IMPORTANT TO EMBRACE CONTEMPORARY ARTISTS THAT REPRESENT WHAT'S HAPPENING NOW. THAT'S WHAT'S INTERESTING"

SUZANNE SYZ

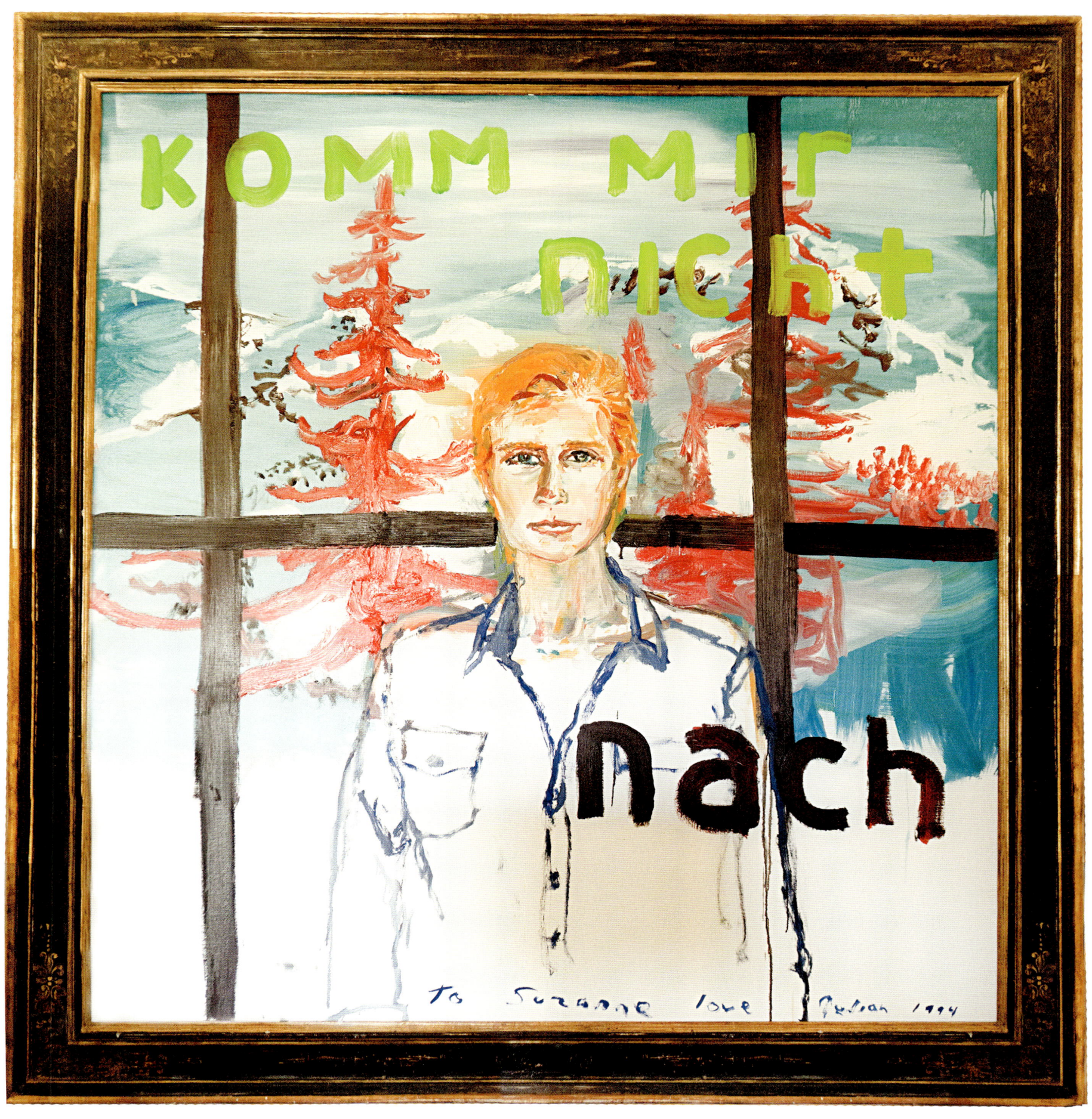

Portrait of Suzanne Syz by Julian Schnabel: *Komm mir dicht nach*, 1994. Oil on canvas, 72.4 x 68.9 inches (184 x 175 cm).

B

Boudoir

Your showroom is like a boudoir: What does it represent for you? The boudoir is a place for impassioned discussions, but it was also the Marquis de Sade's favorite room! It's where you display not only your creations, but also works of art. Is that significant?

It's an intimate place and it's important to have works of art around: It gives a wonderful atmosphere! The environment where I present my creations is as important as the creations themselves. Works of art can be perceived differently depending on the museum displaying them. It is, above all, a place where I like to welcome people. It's the perfect setting for my jewelry. Some say that it's a reflection of me. I tried to make it feminine, awash with color—a place that tells my story, a universe to be discovered room-by-room, a place that inspires and calms me, an enclave far from prying eyes. I enjoy spending time there with my clients; talking about the artworks on the walls and the objects brought back from my travels; and presenting my latest creations. It's a place that should keep evolving, so I'll change the works of art according to the seasons or my whims. You'll see George Nelson's *Marshmallow* sofa or 1940s-style display cabinets mixed in with contemporary art.

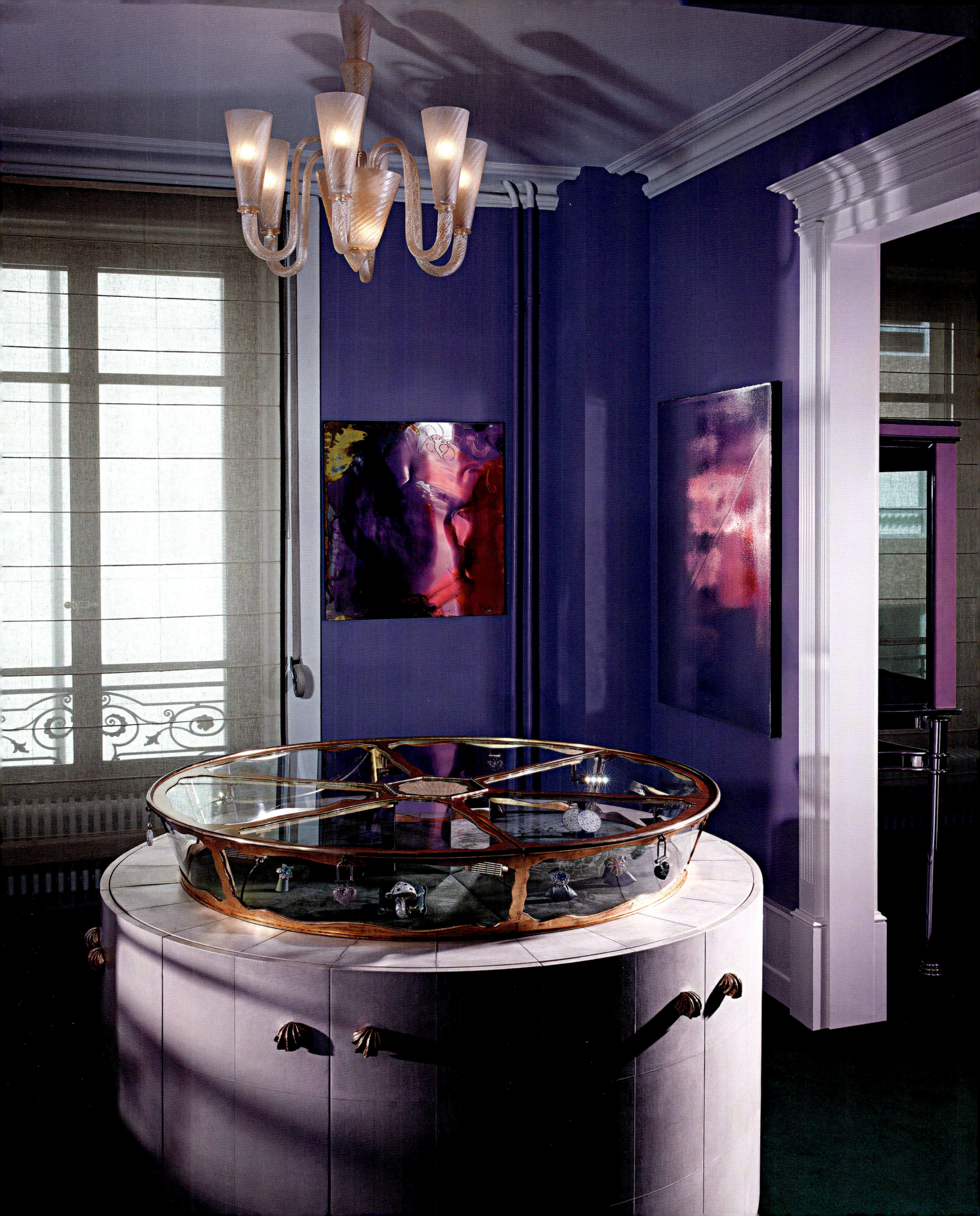

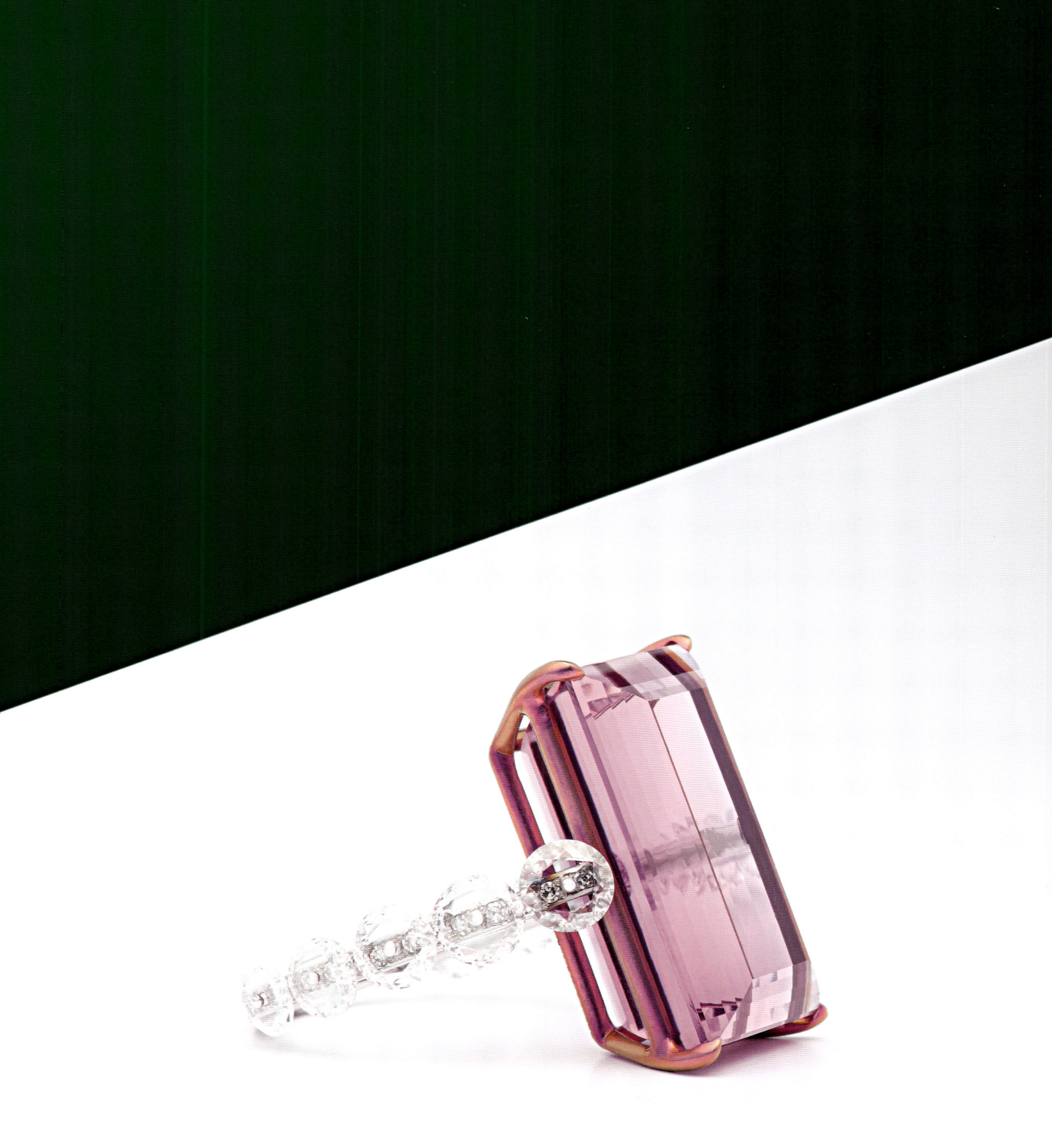

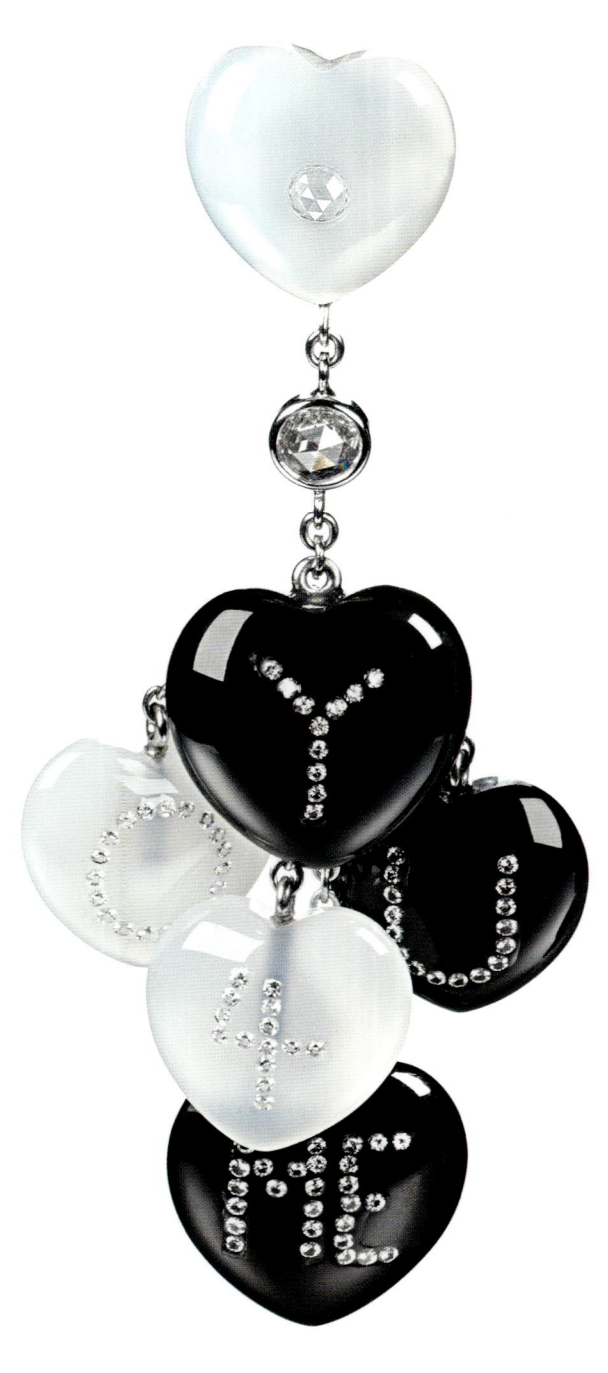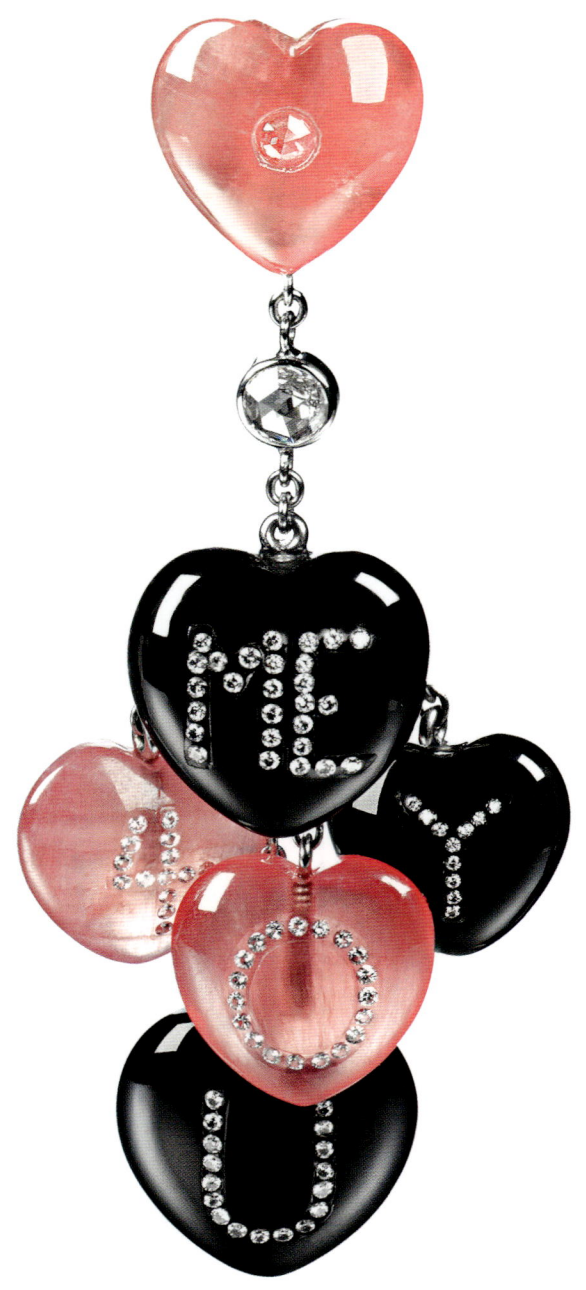

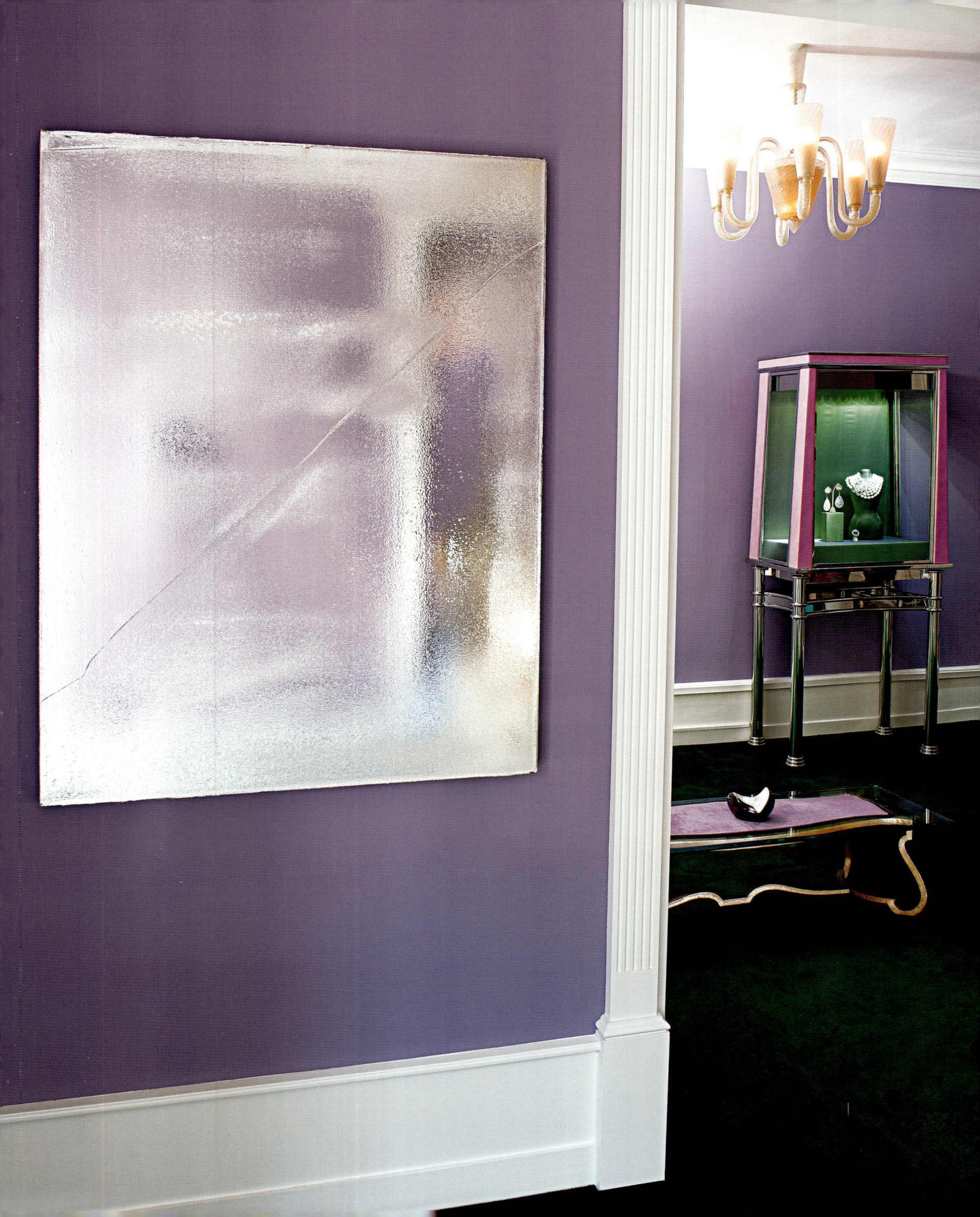

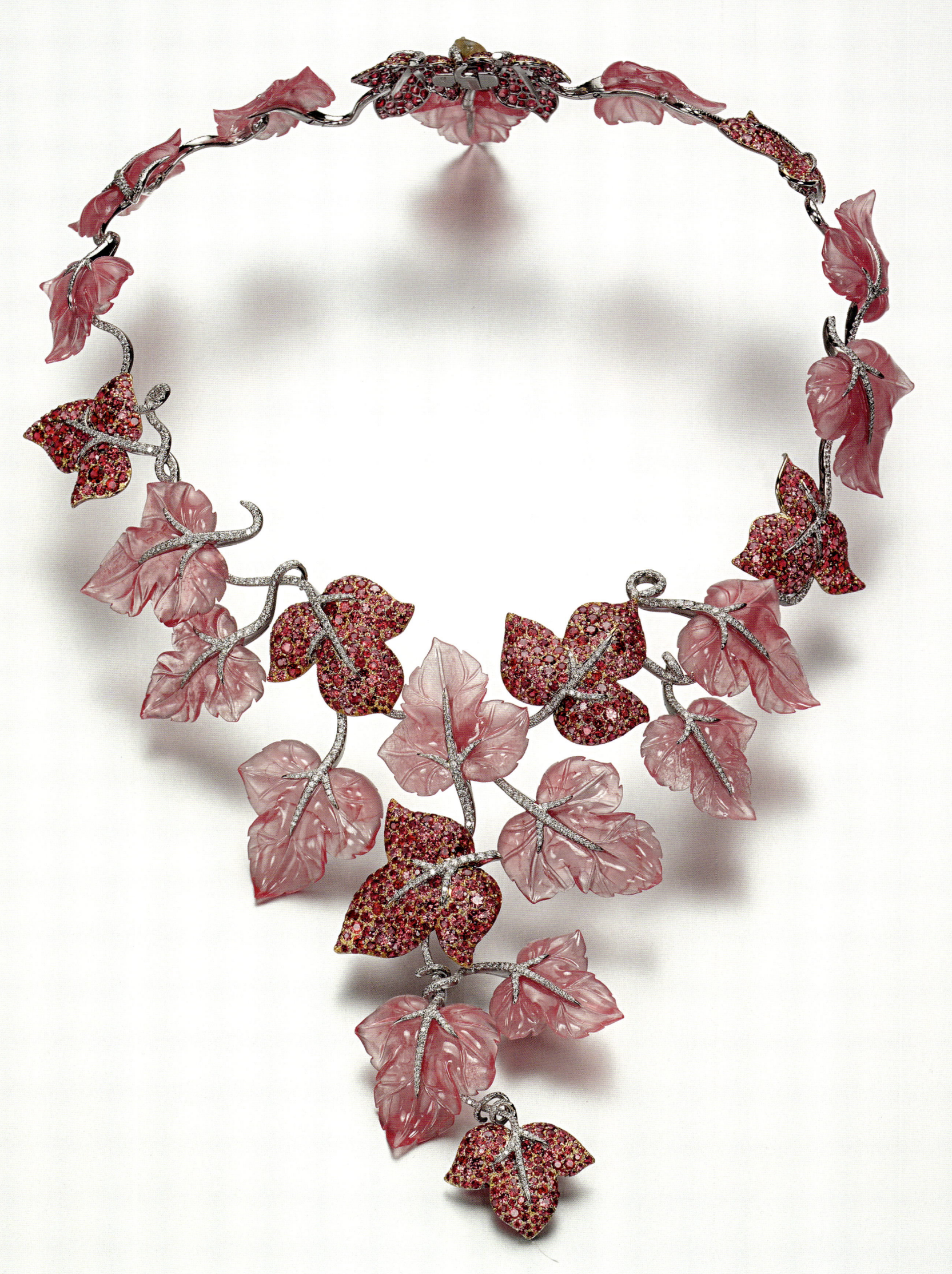

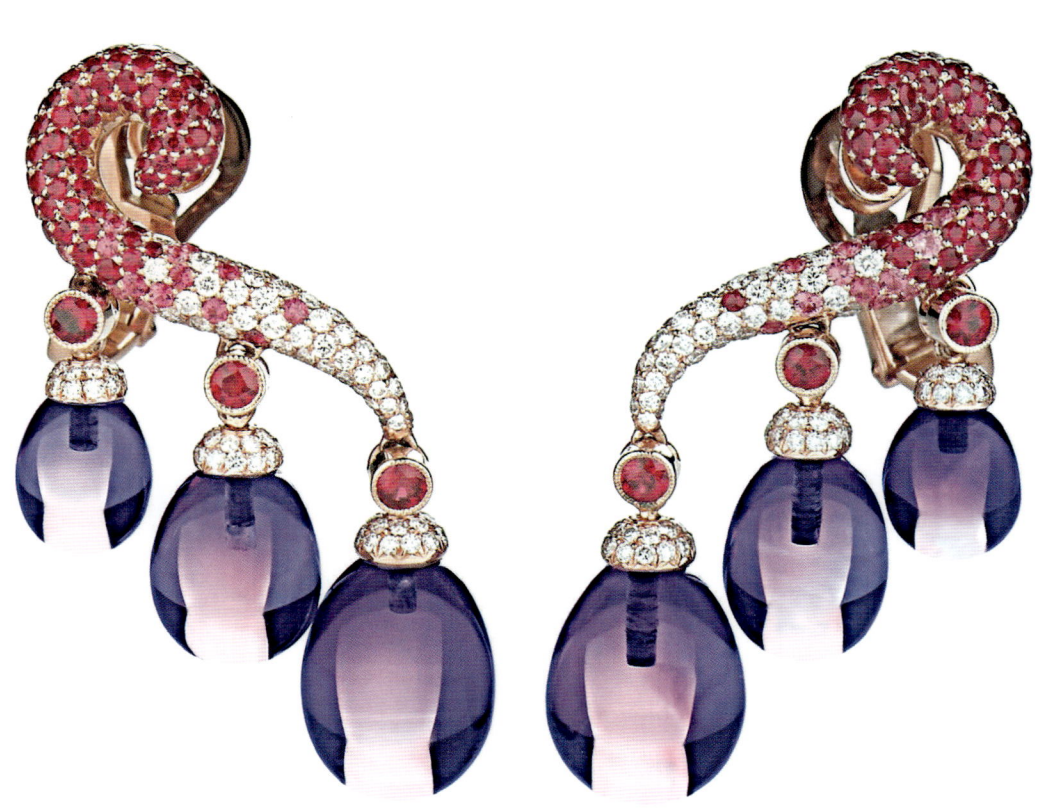

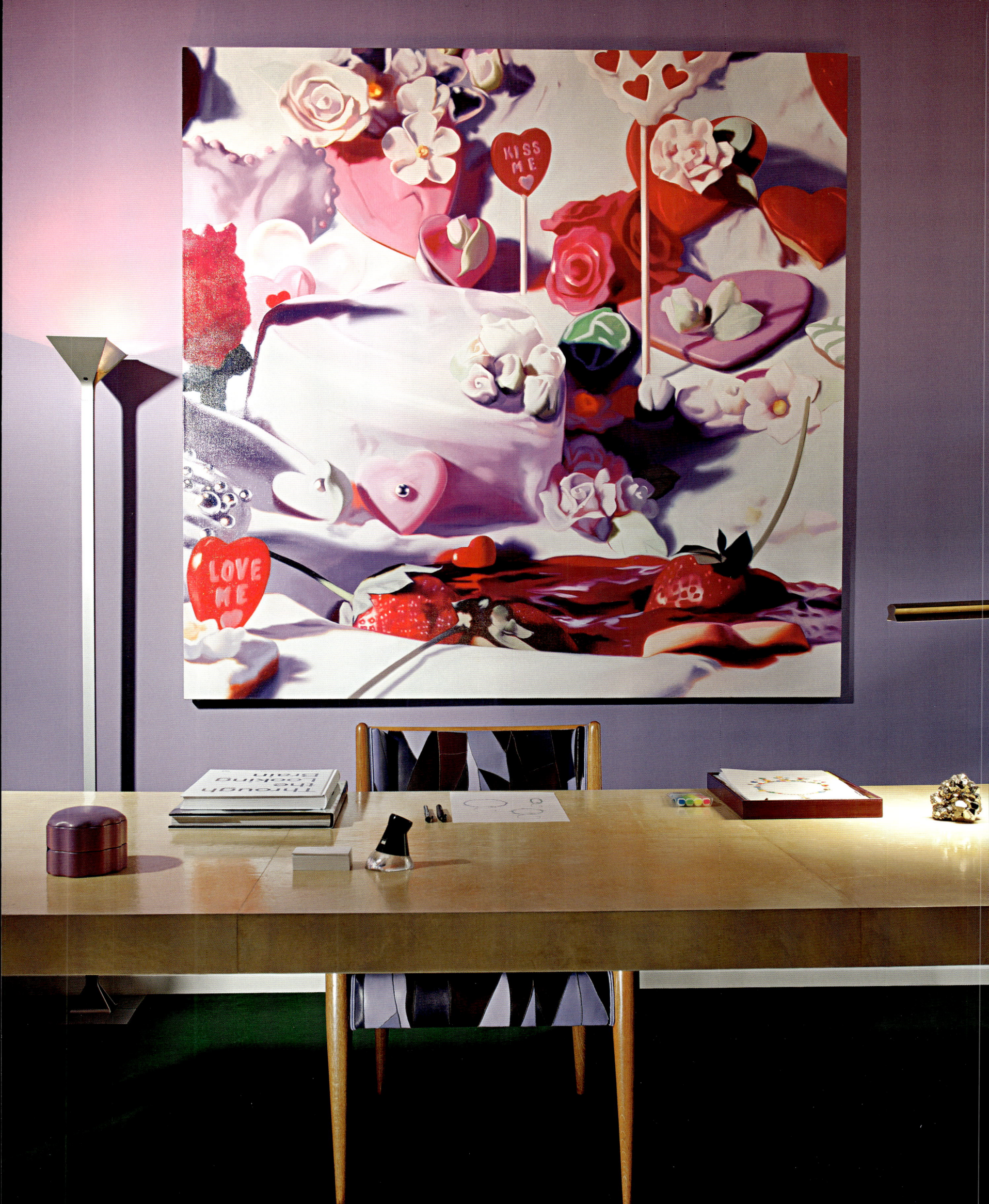

"DIAMONDS ARE SUZANNE'S BEST FRIEND. SHE REALLY ROCKS!"

SYLVIE FLEURY

C

Contemporary

What does contemporary mean to you?

The feeling of the moment, the current mood... One category of my collection is called *Contemporary* and includes my most special creations, those that feature the technical, technological, and Geneva's best savoir-faire. I like to push the limits, always go further, and borrow materials from other fields for my fine jewelry. The one-of-a-kind piece, nº 306 *Touched by a Fairy*, is a good example: I chose elastic titanium thread—normally used in medical procedures—so that the bracelet could fit any wrist and also be worn as a necklace. The pieces made with this material are very light, which is another advantage. The *Contemporary* jewelry pieces are more abstract and avant-garde in their design: They don't look like anything you'll find elsewhere and—like all my creations—each is unique. I think of them either as sculptures or installations. This collection really reflects my passion for contemporary art.

Many art collectors buy your jewelry. Do you think they see a connection between art and jewelry?

Yes, many of my clients like the fact that much inspiration comes from contemporary art; materials like titanium, zirconium, which I often treat as sculptural elements; or the quality or variety of the stones, which are sometimes left in their rough state. This sets me apart from other designers. My clients also love the casual designs that have a little pop art flavor, like the *Life Savers*, *Smileys*, or *Smarties*.

Following page: Martin Creed, *Work No. 338 Things*, 2004. White neon, 6 inches (15.2 cm) high; one second on/one second off. Image courtesy the artist and Hauser & Wirth. Photo: © Barbora Gerny.

THINGS

Peter Fischli and David Weiss, *Ordnung und Reinlichkeit (14)* (*Order and Cleanliness*, detail), 1980–2003. Black and white photocopy, fifteen parts, each 13.4 x 18 inches (34 x 46 cm).

z.B:
kopf-mensch

etc.

You often exhibit your creations in contemporary art galleries like Hauser & Wirth in London, Ben Brown Fine Arts in Hong Kong, and Marianne Boesky Gallery in New York. Why there?

I have always felt comfortable in the art world, and galleries seemed like the right place to show my own works of art. I wanted the public to view them as little pieces of art. Iwan Wirth, who is both a friend and a client, suggested that I have a show in London in the gallery he shared with Colnaghi on Bond Street. I instinctively chose the right path.

Blair Thurman, *Reverse Sex Pistol*, 2007. Neon, 16.5 x 7.1 x 3.5 inches (42 x 18 x 9 cm).

"I WANT MY CREATIONS TO BE OUTSTANDING AND WITTY. THAT'S MY SIGNATURE."

SUZANNE SYZ

Kerstin Brätsch, *Untitled*, 2011. Oil on mylar, three parts:
68.5 x 48 inches (174 x 121.9 cm), 70 x 48 inches (177.8 x 121.9 cm), 69 x 48 inches (175.3 x 121.9 cm).

D

Dreams of Diamonds

What were your dreams when you were a little girl?

When I was little, I loved to play with my grandmother's jewelry. I used to collect small stones I found when walking in the mountains with my grandfather. One day, I found my first piece of crystal. It was so pretty that I eventually had an entire collection of crystals and other stones. Rough gems still inspire me today, such as diamonds, sapphires, spinels, or Mandarin garnets.

What are your dreams today?

To create jewelry that makes you dream, jewelry that makes you laugh, that makes you happy. It's such a pleasure to see my clients' faces light up when they try on a one-of-a kind piece that's right for them. It makes me happy when they send a picture of themselves wearing my jewelry. In a way, I'm sharing their journey during the happy moments of their lives.

And the diamonds of your dreams?

I love colored diamonds! Diamonds are, of course, the stones of all dreams. It's a stone that usually symbolizes life's happiest moments: an engagement, a wedding, a birth, a birthday, a special occasion—it's the hardest of all gems, the brightest, the rarest. White diamonds are magnificent, but my pop art side prefers them in colors. Recently, one of my clients brought me a diamond in a unique color: green, with brown and yellow hues—an exceptional stone! A gem like that makes its own statement but at the same time requires the most creativity: The setting must show off and enhance the center without overpowering it. I designed a seemingly classic setting, but an expert would immediately recognize the stone setting expertise. Set in three rows, the daffodil diamond's monochromatic shade intensifies the jewel's green center. The ring's refinement and elegance remind me of its owner.

Men are like diamonds, they cannot be polished without friction.

> *Suzanne Syz's fine jewelry is a harmonious balance between humor, beauty, and quality. Her creative work is both modern and personal. I appreciate the beauty of the craftsmanship, the juxtaposition of materials, and the diversity of colors that define her style and seduce.*
>
> JACQUES GRANGE, INTERIOR DECORATOR

E
Eclectic

Following page: Thomas Bayrle, *Distribution* (Birne/rote Version), 1971. Silkscreen print on cardboard, 24 x 30.5 inches (61 x 77.5 cm).

Is it the idea of not being limited to one style? Does having style mean having many different ones? What is the style that defines you?

Eclectic is the way I furnish my homes! I'm definitely not limited to one style or any specific theme unless when I'm decorating. I surround myself with things I love and take the liberty to mix styles. Style and taste often go hand-in-hand. The eclecticism in everything around me surely comes from my sense of freedom and curiosity. The common denominator would be pleasure: I'm just as happy having a picnic with friends on a beach in Portugal as I am discovering a great chef's latest creation. My love for diversity is reflected in my jewelry; in the way I decorate my homes; in our art collection; and in my daily life. Being an eclectic collector already gives you a different style. I can draw from several sources and I'm pleased with the results [laughter].

You are never indecisive when you make a choice; you are direct and fearless. When you step into a gallery, you would not hesitate to buy the most controversial Cindy Sherman or a K8 Hardy that some might find shocking. It's as if you perceive an element of freedom in what's considered controversial.

Yes, I think that's the way I am. I'm always willing to take a risk, especially an interesting one. And I believe that in life, you

Louise Bourgeois, *Untitled*, 2006. Fabric and fabric collage, 20 x 26.75 inches (50.8 x 67.9 cm).
Art: © Louise Bourgeois Trust/Licensed by VAGA, New York, NY.

must take risks to arrive at an interesting result. Something speaks to me, or it doesn't; it's a matter of instinct, probably my somewhat artistic side. I can't always tell you why I like something or not. It's a feeling and what's certain is that I like art to be powerful, which may not necessarily be what's the most pleasant.

Should art be a platform for freedom?

Yes, absolutely. Art must push its limits as well as our own. And I believe that freedom in any field of creativity is essential. We aspire to freedom, but people often set limits on themselves through their education and surroundings. It's important to go beyond the limits imposed by the bourgeoisie.

F

Family

Above: Polaroid of Suzanne and Marc Syz, taken by Andy Warhol. *Opposite:* Andy Warhol, *Suzanne and Marc Syz*, 1982. Silkscreen ink on linen, 40.2 x 40.2 inches (102 x 102 cm).

Besides your own close family, which family do you feel connected to? A family of artists? A family of ideas?

I've always felt connected to the family of artists and the vibrations of their ideas.

Tell me about Warhol and the portrait he made of you and your son.

Eric wanted to give me a Warhol portrait after my son, Marc's birth. I was a little hesitant because there was something slightly 'dowager from Fifth Avenue who hangs her portrait in the dining room' about it. So I decided to do my portrait with Marc, which would be a nice souvenir for the coming years.

How does that work? Did you call the Warhol Factory and say: 'Hello, I would like to have my portrait done'?

No, Bruno Bischofberger arranged it. So off we went one morning to the shoot. The Factory was right below where we lived, in Union Square. When we arrived, they sent me to be made up. I was a little surprised and not really thrilled about it. At the time, I had short hair, didn't wear any makeup, and was very casual. They used white powder all over my face; I looked like a ghost. When Marc saw me, he barely recognized me and started crying. We stayed there for several hours and they took lots of photographs; it was a nightmare for Marc. I still have the polaroids from that day! Three weeks later, the studio called and asked me to come by and see what they had done. I was disappointed: I wasn't smiling, my lips were pinched like most people in his paintings—I didn't recognize myself! I thought: 'Well, this is expensive, I should at least be pleased with the result!' So I summoned my courage and told Andy, 'But this is not me!' [laughter] He looked at me and said, 'What do you mean?' So I explained that I was someone who laughed a lot and a happy, positive person,

and that in his image I looked too serious when just the opposite was true. And especially, that it was going to be a souvenir for my son. He asked me, 'How would you like it to look?' So we talked and he took some photographs. Several days later, he personally called me, 'Come and see!' I was a little afraid—I didn't know if he was going to be annoyed with me not being perfectly happy with his work. It was pretty nervy of me because Andy Warhol was a star and diva. In the end, he was adorable and I loved the photos. Then he said, 'Look, I made you three different portraits, three choices. If you like, you can have all three for the same price.' So I answered, 'Well, that's really fantastic!' [laughter] If you didn't know him, he could be very reserved, but once you got to know him, he was very nice and funny. He always had his camera with him, to be ready for any amusing situation that might present itself. Some of those moments are captured in the *Stitched Photographs* that we bought later on. They were fabulous; he shot pictures when he was out at night, like the paparazzi—not everyone was happy about it.

G

Glamour

What kind of glamour, Hollywood glamour? Fashion glamour? Who are your favorite celebrities?

Liz Taylor represents Hollywood glamour! For me, that was real glamour! And she was one of my first clients. I would also mention Michelle Yeoh, Gloria von Thurn und Taxis, and Corinne Flick—three glamorous women. Michelle has always been a great source of inspiration for me; she is a woman of considerable intelligence and her inner beauty is unequaled. And Gloria has been a dear friend for a long time; everyone knows her unique style from the 1980s. And there are many more of my glamorous friends.

❝ *Liz Taylor represents Hollywood glamour! For me, that was real glamour! And she was one of my first clients.* ❞

SUZANNE SYZ

Gary Lee Boas, *Liz Taylor, (Hotel Lombardi NY, 1976)*, 2001. C-print, 15.7 x 15.7 inches (40 x 40 cm).

> *I admire my friend Suzanne's work because of her artistic inspiration. Her jewelry combines the spirit of today with the art and craftsmanship of* haute joaillerie. *Each piece is a celebration of unique taste. It is a joy to wear Suzanne's creations.*

Dr. Corinne Michaela Flick

> " *Suzanne's artistry is simply divine.* "
>
> MICHELLE YEOH, ACTRESS

Edward Steichen, *Gloria Swanson*, 1924. Black and white vintage gelatin silver contact print, 9.8 x 7.9 inches (24.8 x 20 cm). Steichen/*Vanity Fair*; © Condé Nast.

H

Happy

What is your secret for happiness?

To have the freedom to do what I love. I'm also very lucky to be surrounded by people who watch over both my freedom and happiness. My children, husband, mother, brothers, friends... Each person contributes in his or her own way to my happiness. I'm also lucky to know artists who are full of dreams and enjoy independence. I've always had positive people around me, in my private life as well as in my professional life, and that undoubtedly contributes to my happiness.

Humor

Above: Andy Warhol, *Jean-Michel Basquiat Eating*, 1976. Black and white stitched silver gelatin prints, 40.9 x 31.5 inches (104 x 80 cm). *Opposite:* Jean-Michel Basquiat, *Your Teeth*, 1982. Pen on linen, 23. 6 x 15.7 inches (60 x 40 cm).

Is humor important, and why? Is humor possible and acceptable in the world of fine jewelry?

It's essential and very important to me. People who know me will tell you how much I like to laugh. So much so that Jean-Michel Basquiat drew my teeth on a napkin at my birthday party in New York in the 1980s. It's essential to not take life and yourself too seriously; a good laugh is like medicine. In the jewelry world, a serious stone is more wearable and young if it's set with some humor. I like designing jewelry that makes you smile. Many of those pieces are in my *Pop* collection: the *Smileys, Smarties, Life Savers, Me 4 U,* and *U 4 Me* are just some examples.

OPDODO
YOUR TEETH

JEAN
—
MI CHEL

George Condo, *Big Red*, 1996. Oil on canvas, 15.7 x 12 inches (40 x 30.5cm).

"I LIKE TO MAKE PIECES THAT DEFY THE ORDINARY, OTHERWISE IT'S NO FUN."

SUZANNE SYZ

> *It's such a pleasure to see my clients' faces light up when they try on a one-of-a kind piece that's right for them. It makes me happy when they send a picture of themselves wearing my jewelry. In a way, I'm sharing their journey during the happy moments of their lives.*
>
> Suzanne Syz

> *Love is certainly a motivating force in my work. I think feelings are the motivating force for all artists.*
>
> Suzanne Syz

> *What matters most is that each of my friends and clients are the queen of the ball, and that when they wear my jewelry they feel beautiful and admired.*
>
> Suzanne Syz

I

Inspiration

Who has inspired you?

Corinne Flick, a dear friend, who is graceful and elegant and who has worn my jewelry so beautifully since the very beginning. Viviane de Witt, a friend and one of my first clients; she supported and pushed me from the start to show my jewelry to the Parisian press. And of course, the actress Michelle Yeoh, who constantly reinvents herself in her films—an exceptional person who beautifully wears my creations. In my pieces, specifically the *Pop Art* ones, the mix of colors was undeniably inspired by the years I spent in New York and the artists I met there.

Which countries or which trips do you remember best? Which one makes you dream?

Ten years ago, I visited Burma and it really inspired me. The country was still untouched—it was wonderful. The Bagan temples, ochre colors, and sunsets that revealed all the stupas of the Burmese jungle. And Cambodia, with its rich vegetation and amazing temples of Angkor! It's a part of the world whose culture is as astonishing as its people. But I have special memories of many other trips. Also, traveling in the Omani desert (we were invited by Sultan Shabib bin Taimur's nephew), where I experienced an incredible silence that only exists in the desert, and the beauty of never-ending dunes. The same profound feeling, but in a different way, that I had before the powerful and endless Great Wall of China. Such strong impressions from their travels inspire all artists. One story from a summer vacation on a boat in Greece: Nicolas, my son, was afraid of dark water and I had to invent something interesting to get him in. So we went looking for sea urchins in every color and dried them on the boat. He was amazed by the sublime colors, as was I. That was how I came to create my first pieces from sea urchins!

Suzanne Syz, a red-headed flame with a wonderful, attentive sensibility, full of warmth, intelligence, and tenderness. I remember those bizarre earrings, with one in the shape of a sun and the other in a moon. They were enough to convince me to get to know this elegant person almost fifteen years ago. Friendship is like love because you can also fall 'in friendship.' This was the case for us. Here are some examples: Suzanne, one day you had the courage to bring a small suitcase to my Tour Pressy home during a luncheon. You opened it and I held my breath. You waited, scrutinizing my reactions with an artist's discernment. It was an enchantment! My first vision was a facetious, sparkling mushroom with autumn leaves as the collar; a ripe fig with a purple crevice in an ocean of green foliage; leaves of overlapping rubies; and a question mark the color of fire that has since become my favorite piece of jewelry. It was pure amazement. We decided to do an exhibition in Paris together. All of Paris came along with many of our foreign friends. You garnered an immense success and then stole the scene in several other cities, showing your one-of-a-kind creations, because you believe in never copying your magic jewelry. I remember those dream-inducing earrings—in the form of chandeliers with spider-like diamonds—that I didn't end up getting. I regret that so much and you will never make them again. Suzanne is elegance, fantasy, and imagination personified. After several years, you selected strange, rare stones that you set in a ring. The sparkle of a shimmering stone nourishes your imagination, and you escape into your beautiful creations. Your flowered gardens are your heaven, and you translated them into precious accessories that render us all so happy. The beloved warm light of Tuscany is radiated into your creations. Suzanne, you are a red-headed, magical fairy of sparkling gems. Suzanne, you are an extraordinary vector of beauty. Your unconditional friend.

COUNTESS VIVIANE DE WITT

And for your jewelry, where does your inspiration come from?

I'm self-taught, so I operate on intuition. Many things inspire me: It could be a video I watch while I'm at the gym; an artist's work I view at a fair; nature; or just something I discover when I'm traveling. Inspiration comes from everywhere.

How do you actually create something? What is the process?

A few years ago, I saw some barbed wire and thought it looked like an interesting material. I thought about how I could use it because it had a very contemporary look. I made earrings out of colored titanium to give them a 'couture' feeling and set them with diamonds. Women adore them! Another time, when I was at an Axel Vervoordt exhibition at the Paris Biennale des Antiquaires, I saw a collection of seventeenth-century wood spheres that looked similar to the ones I had seen in Hong Kong by the artist Ai Weiwei. I thought they were wonderful and was inspired to make earrings in the shape of blue spheres. Most of the time, I start with a drawing and rework it several times. Then the atelier puts its talent to work and makes the piece while regularly consulting with me.

How much time goes by between the inspiration and the finished product?

Inspiration can take time to ripen and sometimes I'm ahead of the times. From the day we start modeling from my sketch it can take up to a year until the piece is finished; sometimes we start over again if the result is not satisfying to me!

Elaine Sturtevant, *Warhol Flowers 8*, 1969–1970. Synthetic polymer and acrylic on canvas, 11.2 x 11.2 inches (28.5 x 28.5 cm).

100

"THE MOST JOYFUL MOMENT COMES WHEN MY PIECES ARE CHOSEN BY A WOMAN WHO BRINGS THEM TO LIFE."

SUZANNE SYZ

J

Joy

Is it important? Why? Does it drive you?

Yes, it's important. Being positive and bringing happiness to those you love is a driving force. It's also a joy to be able to create!

Does jewelry bring joy?

Jewelry must bring joy and happiness. It's often a reminder of a happy moment, a birthday, an engagement, or a Christmas present!

What else brings joy in your life?

My family, my friends, my dogs! Wonderful trips around the globe discovering new places and people. Reading in my garden and walks with the dogs!

Is it possible for jewelry to express the notion of joy? How?

Jewelry expresses or brings joy in the way it's made. I have a lot of clients who say, 'When I wear your jewelry, it represents you, and you are such a joyful, positive person. I can feel that in the pieces you've created.' It can also be through the choice of stones or colors. The way I mix colors can evoke a special feeling.

Is there a particular moment in your life, or in your career, that you would particularly associate with being joyful?

Quite a few! Professionally, I think it would be when I founded my company. Specifically, after I put my collection together after four years of hard work, and when I finally had my first presentation in Paris. It was a big moment of joy and happiness. When you're an artist, you always doubt how people will react to your work. It's such a relief and big joy when you show it to people and they react well. An immense joy comes from creating my jewelry designs. When all of the technical obstacles are overcome, I feel a great satisfaction. The most joyful moment comes when my pieces are chosen by a woman who brings them to life.

K

Kaleidoscope

What is your relationship with kaleidoscopes?

I've always admired this dream-filled toy: the light, colors, and changing forms that create tableaux vivants. I can see paintings, sculptures, or jewelry. Such a simple object can transport you. Last year I had fun designing an invitation by placing my pieces of jewelry inside a geometric shape. My own kaleidoscope was born!

113

SUZANNE SYZ

2012

" *Suzanne and I first met at Rolf Sachs's home in Bavaria about eleven years ago. After that weekend we became very close friends. It was [friendship] at first sight. Around that time she started her career as a jewelry designer. She showed me some of her first pieces and I was thrilled and convinced from the spot that she had real talent. Her jewelry is amazing! Beautiful precious stones made into fantastic and extremely creative composures. You must just love every single piece! Each is one-of-a-kind and of the finest craftsmanship! I am happy that she is so successful! I hope that she transforms her exciting ideas into many more wonderful pieces of jewelry.* "

I.K.H. Prinzessin Floria von Hessen

L
Love (for Dogs)

Is love a motivating force for your designs?

Yes, definitely. Love is certainly a motivating force in my work. I think feelings are the motivating force for all artists: Love, hate, sadness, and happiness are expressed in their work. I have been lucky in this respect: Love and joy have been my driving impulses. A piece of jewelry is often a link of love between people, so it should be based on love.

Tell us about your passion for dogs.

Since I was a little girl, I've always had dogs in my life. Dogs express their unconditional love and ask nothing in return. I love them! At the moment I have three dogs. I've had eight in total and they were wonderful company! My husband was sweet enough to give me a bracelet with portraits of all the dogs. It's a technical feat: Each dog's portrait is engraved on a hand-painted rock crystal, and secured on a mother-of-pearl plate set with champagne and brownish diamonds on pink gold. The name of each dog is engraved on the back and there are bones made of horn to connect them. A wonderful piece, and now I always have them with me!

M

My Homes

" *Suzanne approaches home design the way others create paintings or compose music. Musically, it could be a duet with Jacques Grange or myself. Her sense of artistry is visible in all her homes. She brings the same inspired enthusiasm to her designs as she does her jewelry. She is an excellent team leader! The Paris apartment was where we first met. She asked for help and we immediately realized that we shared the same taste for whimsy, comfort, and individualism. I got to know her. She has very eclectic taste and likes antiquity, design, and contemporary art. Our exchange of ideas was the start of our friendship. Strangely—and I realize this only now—I thought that apartment (in Paris) was a kind of jewel box for Suzanne. The concept of jewelry was not far behind… Suzanne came to visit us, Jacques and I, in Portugal. She loved the wilderness at our place near the Atlantic Ocean, and before the end of her stay she had bought a cabin (Suzanne reacts quickly). Jacques was the architect. The three of us believe in the same philosophy; hold the same respect for places in their natural settings; and are drawn to an easygoing lifestyle. Furnishing the fisherman's cabana and working on the garden are what we enjoy most when we're in Portugal. Caspri was a great adventure! Without Suzanne's tenacity, the vineyard would have never been brought back to life. The house was in ruins and the vines had been abandoned. Against everyone's advice, Suzanne blazed ahead with the project. I was surprised to discover another side of her personality: Behind the artist was a formidable military leader. In the macho Italian world she always had the last word. Jacques helped us with the layout: The wine storehouses became the living areas and the old reception rooms were turned into magnificent bedrooms. The oversize common rooms were the ideal backdrop for Suzanne's contemporary art. As for the furnishings, we were in perfect agreement since we both like what's unconventional. For each of her homes, our audacity of design always respected the location, whether it was the idea of being in Paris, Portugal, or Italy. The real secret—one that was easy to share with Suzanne—was that you must love your home. Love works miracles!* "

PIERRE PASSEBON, GALLERIST

Where do you feel most at home?

In Comporta, Portugal and in Italy, at Caspri. The wilderness of both places is so appealing. I like to be close to nature, to be able to go out and walk on the beach or in the vineyards.

For someone who travels as much as you do, how important is it to be 'at home'?

It's very important to have a home base. I'm lucky to have several cozy home bases, where I can return and relax after long trips.

"WITH THE EYE OF A COLLECTOR, THE VISION OF AN ARTIST, AND WITH THE SENSIBILITY OF A WOMAN, SUZANNE HAS BEEN MAKING JEWELRY OF OUTSTANDING BEAUTY AND QUALITY. MANUELA AND I FELL IT LOVE WITH SUZANNE'S PIECES YEARS AGO AND NOT ONLY HAVE WE BEEN ABLE TO COLLECT THEM, BUT WE WERE ALSO PRIVILEGED TO EXHIBIT THEM IN OUR GALLERY."

IWAN WIRTH, ART DEALER

N
Nature

Is it important for you to go back to nature?

Yes, it's essential. For example, our hunting grounds in Austria represent a truly extraordinary side of nature. You can hear the deer bellowing, which can make you feel like you're in the Middle Age; it's very strong, very intense. At Caspri, in Tuscany, I always take the dogs for long walks and you're in the midst of rabbits, pheasants, and the sounds of birds! Those are powerful moments, when you're in nature and become one with it. The noises, smells, wind—every feeling is intensified. The dogs play and run all over. These are the privileged moments that inspire and allow me to recharge my batteries.

It is also in nature that you find the rough materials you use for your jewelry designs.

I particularly like to be challenged by the materials I use. For example, right now I'm working with zirconium, a metal similar to titanium. It allows me to put more stones on an earring without weighing it down, making it easier to wear—a notion that men who design jewelry can sometimes overlook. The titanium can be colored in crazy hues and its surface can be altered, which is really interesting.

The *Dragon* bracelet, for example…

That was a piece I'd been dreaming about for some time. We worked on it for seven or eight months. It's made of titanium. The combined colors create an 'aqua-green' shade that's perfect for the dragon. We worked with different craftsmen: some that specialized in the use of this material; others with the setting; and a specialist for the animal shapes. It's always exciting and interesting to work with these teams. The Chinese Year of the Dragon was also a source of inspiration, but I wanted my creation to be different than what other artists were doing to mark the occasion.

O
Only You

Exclusivity is at the heart of fine jewelry and art. Collectors are always on the lookout for a one-of-a-kind piece. What does the notion of exclusivity and rarity mean for you?

I design exclusive pieces of jewelry for unique women! I have them in mind when I create jewelry. You can spend a fortune on a piece and be at an event where another woman is wearing the exact same one. That's why the idea of exclusivity is so important in my designs. Each piece of jewelry exists only once. Some casual designs are repeated, but in different colors, so that there will never be the same piece in the same color—regardless of my clients' demands! This can sometimes lead to disappointment, but in the end I believe my clients come back to me for that very reason. As in the art world, my clients and collectors are on the lookout for one-of-a-kind creations. In the art world, the notions of exclusivity and rarity—regardless of the object—signify to collectors that a piece will keep its value in the market.

And if one of your clients were to say to you, 'I love that! I want the same one.'

We make no exceptions, ever!

P

Precious

How would you define 'precious'?

Firstly, it's about the materials: unique gemstones that people find around the world. But that includes more than just the stones that are considered precious, such as diamonds, rubies, sapphires, and emeralds. Today, there are many kinds of gemstones and they're all precious. Paraïba tourmalines, spinels, Padparadja sapphires, and tanzanites are all incredible. The word 'precious' is also attributed to all my dear friends that I am lucky to have.

❝ *When I first met Suzanne in the early 1990s, she stood out with her daring sense of color amongst the other women clad in beige like me. I recall vivid greens combined with shades of purple all set off by a mane of red hair. She would be wearing a beautiful, unusual piece of jewelry designed by herself that always caught my attention. Luckily for us, her friends and clients, Suzanne decided to share her innate style and wonderful sense of color. She creates not only objects of desire but jewelry that is original and imaginative, and she manages to come up with new ideas on a theme that is as old as mankind.* ❞

KATRINE HENKEL, ART DEALER

> *" Suzanne's creations are unexpected and innovative, but always of the highest quality: She truly makes fine jewelry. "*
>
> Almine Ruiz-Picasso, art dealer

" *During a time when modernity fascinates everyone—not only with art but also with jewelry—Suzanne Syz is one of the noteworthy artists who allies quality with humor, luxury with ridicule. In her universe, each piece seduces the viewer with an excess of color and unusual materials. Thanks to her unusual training in this industry, as well as her contemporary sensibility, she aids in fueling the twenty-first century's energy, where the worlds of art and jewelry merge as one.* "

FRANÇOIS CURIEL, PRESIDENT OF CHRISTIE'S ASIA

" *Jewels created by Susanne Syz are fun, sexy, and sparkling— exactly like herself!* "

SIMON DE PURY, ART AUCTIONEER AND COLLECTOR

" The elegant slender lines of Suzanne Syz's delightfully playful jewels are a gift of joy; she uses unusual materials to create whisps of diamonds to light up a wearer's face. Ordinary objects are interpreted with brio, exquisitely set with precious gemstones, and vibrant colors are celebrated in her Life Savers *and* Candy *collections. The workmanship and the quality of her gemstones is next to none; nothing is left to chance and the result is a fairy godmother's gift to us all. "*

Julie de la Rochefoucault, jewelry consultant and writer

❝ *Suzanne always keeps women in mind when making her creations, and she embellishes them with cheerfulness; it's the recognizable 'Suzanne touch.'* ❞

FRANÇOISE DUMAS, PUBLIC RELATIONS CONSULTANT

Q

Queens

Do you count royal queens among your friends?

There are queens, yes, but not only in the sense of nobility, even though many of my clients and friends are beautiful European princesses. What matters most is that each of my friends and clients are the queen of the ball, and that when they wear my jewelry they feel beautiful and admired.

Are there any queens that particularly influence or inspire you?

Yes, Michelle Yeoh is an inspiration. I love creating for her. But I'm also influenced by my clients' styles and needs.

What kind of jewelry do you make that would be suitable for a queen?

The fairy tale–inspired pieces, especially my first piece, *The Frog*. When I started out, I looked to the Grimm brothers for inspiration and thought about the frog who became a prince.

Did you ever have dreams of being a princess when you were young?

Better than a dream! I was five years old, when I began ballet and participated in 'fairy tale' performances. I played a little princess and had makeup, costumes, and crowns. It was all very exciting!

What does being a queen mean for you?

Being an example, being responsible, and fulfilling your duties. Taking care of people. Representing your family and serving your country the best you can.

"SUZANNE'S PIECES OF JEWELRY ARE FULL OF JOY, HUMOR, AND FANTASY. SHE MAKES PIECES THAT COME OUT OF A FAIRY TALE, WHERE A LITTLE PRINCESS DREAMS OF TURNING THINGS SHE LOVES INTO FINE JEWELRY. TOYS, FLOWERS, LITTLE INSECTS. ANYTHING SHE LOVES SHE TURNS INTO A JEWEL. WHAT COMES ACROSS AS SUZANNE'S PLAYTIME IS HER PASSION FOR PERFECTION AND AESTHETICS. PLEASE MAKE MANY MORE DIAMONDS, EMERALDS, AND RUBY TOYS."

I.D. DIE FÜRSTIN GLORIA VON THURN UND TAXIS

R

Rainbow

Do you like rainbows?

I think rainbows are magical and I use their colors for my jewelry.

What is your favorite color?

I have several. But my favorite color is Paraïba blue. It's hard to describe; it's not really blue, more like turquoise green—a very specific color. It's a stone that shines very bright, even at night! It's relatively new, discovered in the early 1980s in the Paraïba region of Brazil. It has a composition that contains copper and gold, which contributes to its exceptional brilliance, shine, and color. Paraïbas are increasingly hard to come by, and so they've become more exclusive than diamonds. My *Lotus* ring is crowned with a Paraïba tourmaline that weighs over fifteen carats. I would be hard-pressed to part with it.

"SUZANNE AND I SHARE A COMMON PASSION: A LOVE FOR COLOR. AND THE FANTASTIC PALETTE THAT SUZANNE USES FOR HER PRECIOUS JEWELRY IS JUST LIKE HER: DELIGHTFUL!"

CHRISTIAN LOUBOUTIN

S

Suzanne

Are you sensitive to criticism? Does it influence you?

Criticism is important and an important part of the creative process. Eric, my husband, is the toughest critic. I like to listen to what he has to say and we discuss it. I like criticism because it's stimulating.

If you had to define yourself in one word?

Perfectionist!

Qualities and shortcomings?

Shortcomings, well, impatience. That's a terrible thing but I'm always good humored!

And the qualities?

[Eric Syz] She has lots of good qualities: She is joyful, very generous, sincere, funny, and witty [laughter]. She has a sense of humor.
[Suzanne] That's not bad... [laughter]

T

Thank-You

Who would you thank and why? Is there anyone in particular who has accompanied you on this journey?

My heart goes out to all of you who have accompanied me through this wonderful adventure in creating jewelry. Without you all, it wouldn't have been possible to be where we are today. It makes my day when I hear that you have worn my jewelry and were the talk of the town! That's my motor everyday: to bring you joy and happy moments while wearing my creations. In particular, I thank my family, who was patient during those years of preparation for the first collection, and for supporting me constantly. My everyday team, the people in my workshops and suppliers, and the people who help me. Assouline, who encouraged and supported me in this project from the start. The creative work of the past ten years has been a team effort. Everyone involved has made a significant contribution and I hope I haven't left anyone out! Thank-you!

Nicolas Filippo Hans
Jean-Marie Sam Hanna
Ben Gabriele Patrick Alain
Arturo

Inside the heart:
- Riprand, Franziska, Florence & Alain, Michaël
- Nancy, Evely, Paolo, Margot, Franziska M., Brigitte & Vladimir, Christopher
- Birgid, Katrin H., Nouran, Jane & Alfredo, Christine & Iain, Rosa, Jill, Gisela, Lisa, Almine
- Tanja & Marwan, Vladimir, Francesca & Urs
- Tatiana, Elisabeth, Lizzie, Martina, Francis, Alexandre
- Selivanova, Hilda, Katy, Jürg, Eric, Marc, Nicolas
- Nicole & Massi, Michelle & Jean
- Peter, Jacque & Chip, Linda, Caryl & Izzie, Anne
- Floria & Don, Dominik, Johanna, Michelle & Olivier
- Pierre & Jacques
- Tania & Issam
- Manuela & Iwan, Viviane, Christian
- Alberto, Corinne, Terry, Krystyna, Katrina, Jessy
- Vladimir

Locomotive: Ariuna, Chris, Irène

Wagon 1: Svetlana, Lamb, Claudia, Yollande, Reto, Zsuzsanna, Belle, Simone, Oksana, Marianne, Boris, Carol, François

Wagon 2: Mohamed, Olivier, François, Alain, David, Daniel, Gabriela, Gilles, Santi, Dilip

U

Up-to-Date

Are there trends in jewelry?

Particular stones can suddenly be in fashion and therefore more expensive. Spinels are a good example: Ten or twelve years ago, they were much less expensive and there was a wider choice than today. Right now they're very much in style. Twenty-five years ago you could buy a colored diamond for a relatively good price whereas today they can cost up to $1,000,000 per carat for a stone of perfect color and of a certain size. Of course there are design trends but a good design is rarely out of fashion!

Are there seasonal trends like in the world of fashion?

No, it's not as radical. One stone or one style will not be in fashion one season and out the next. But there are fashion trends: One year it might be white gold, the next yellow; right now, pink gold is in style. I was one of the first designers to make very colorful jewelry, things that people weren't used to seeing. And now, that's become a trend.

SUZANNE SYZ DELIGHTFUL SWE
FROM THE PURPLE BOUDOIR

WE WILL ROCK YOU…!
Suzanne Syz unique creations from the purple boudoir

Сьюзан Сиз
имеет честь пригласить Вас
на открытие выставки
уникальных ювелирных украшений

27 ноября 2008 года в 20.00
ул. Новокузнецкая, дом 40
R.S.V.P. +7 495 7890134
На два лица

SUZANNE SYZ HIGH VOLTAGE
IN THE PURPLE BOUDOIR

Be my Valentine

FROM THE PURPLE BOUDOIR: FIREWORKS ON STAGE

Exhibition of unique jewels by Suzanne SYZ
From May 13th to May 18th 2011, from 11 am to 7 pm
Opening on Thursday, May 12th 2011, from 6 pm to 9 pm

AT

BEN BROWN FINE ARTS HONG KONG
301 Pedder Building – 12 Pedder Street – Central, Hong Kong

Tel: +852 2522 9600
www.benbrownfinearts.com

SUZANNE SYZ SHOW ROOM
Rue Céard 13 – CH-1204 GENEVA – Switzerland – T +41 22 310 20 84
Email: ariuna@suzannesyz.ch – www.suzannesyz.com

Press contact: Victoria Communications – victoria@victoriapr.com.hk – T +852 6086 1672

V

Views

W

Wine

From Warhol to Caspri

Love of art and love of wine often blend together, because they share the same quest, and the same source: our emotions. So it was ultimately just a single easy step for Suzanne Syz to go from hyper-urban New York to the Tuscan countryside to give new life to the estate of La Fattoria di Caspri—a residence that lay in ruins with neglected vineyards surrounding it. Faced with such a challenge, many would have given up. The way of the vine demands a long apprenticeship—learning the rules, acquiring experience and knowledge, and conducting experiments. But winegrowing is also a domain where the capacity to understand the environment allows you to express your sensibility, develop confidence in your project, and make appropriate choices that lead to good results.

Like the creative artist, the winegrower is nourished from the milieu where she develops her craft. And if she does not consider herself to be an artist, she must absolutely possess an artistic sensibility that goes hand-in-hand with a farmer's "common sense."

From the first time we met, I was struck by the determination Suzanne Syz revealed, declaring, "When I took over the estate in 2006, a renowned viticultural consultant advised me to restructure the vineyards to increase productivity; pull out all the vines, some of which had been untended; and to replant merlot and cabernet sauvignon [grapes]. But I decided not to touch the *terroirs*' structure; to preserve the vines that were in place; and to plant new plots by massal selection, with new vines grafted from our best old ones. I also immediately sought to implement certified organic methods

of cultivation and to apply the guiding principles of biodynamic agriculture. This was simply the natural choice," Syz concluded—proof of her desire to preserve the rural Tuscan province of Arezzo's profound identity and character.

At La Fattoria di Caspri, the earth and its traditions both rule. It is principally the indigenous sangiovese variety of wine grape that has been used to replant the vineyards on the slopes of the Vasca and surrounding hills. Cilliegiolo vines have been preserved as testimony to a local viticultural tradition that has recently tended to disappear. Less noble than sangiovese, cilliogiolo offers a charming rusticity, simplicity, and frankness. If the winemaker maintains a link with the earthly realm by working with vines, the fermentation of grape juice is the first step in the creation of wine itself. In alchemy, fermentation is associated with transmutation. Here again, it is not technique but the spirit that shows the way.

The birth of a wine—like the birth of a work of art—is a process guided by the raw materials at hand and by the soul of the place where the artist or winemaker works, resulting in a correct balance that provokes an emotional response. White grapes are vinified by maceration over the course of many long weeks of fermentation, according to traditional practices long maintained in the area before the destructive influence of modernization. The juice is enriched with tannins extracted by contact with the grape skins, seeds, and stalks, giving the wine vigor, freshness, and density.

Red grapes, harvested "whole crop" for each vintage, likewise macerate in small conical vats. The young wine is interfered with at this stage as little as possible out of respect for its raw materials; next follows patient maturation to allow the wine to develop structure, and bottling without filtration in order not to subtract from what constitutes its essence. Throughout this period, when the wine's birth is preceded by the rebirth of its raw materials, the winemaker must know how to remain attentive to the vintage—how to follow along without forcing, while accepting and maintaining trust in the wine through the rougher, unrewarding phases of its development until it reaches maturity.

Through perseverance and guided by her creative spirit, Suzanne Syz has devoted herself to her new passion. With the help of a winemaker, who is in charge of the estate's day-to-day running, Syz makes natural wines without recourse to any oenological tricks and giving in to passing fashions in winemaking. Together, they emphasize sincerity of expression, refusing any idea of making wine into a cult or an object of speculation. Like the artworks with which she surrounds herself, Syz's wines benefit from a rare quality whose secret she knows.

By desacralizing paintings and sculptures and integrating them into daily life, Syz creates a form of exchange between the artwork and its environment, making it possible for the viewer to rediscover the essence that underlay its creation. In the same way, her wines have no purpose other than to fulfill her initial aim: to bring people together, refresh them, give them pleasure and joy, and lift their temperaments.

Now that the sixth vintage has been put in the cellars, it is time to take stock of the distance traveled over these last few years. The soil has been renewed, the equilibrium of the vines restored, and each year the wines grow in subtlety. La Fattoria has been reborn, and the estate's wines are once again fulfilling their primordial role, which is to create social, cultural, and intellectual links among those who taste them.

What could be lovelier than sharing a bottle of *rosso* and some Tuscan *salumi* while watching the sunset behind the hill of Poggio Cuccule? Then letting that emotion wash over you, taking pleasure, for good reason, in the gentle intoxication the wine's spirit brings?

—Philippe Bon, writer

X
Xmas Cards

Christmas cards are important to you: How do you choose them? Why has this become a tradition?

This has been a tradition in our family for thirty years! It's a way to stay in touch with our family members and friends who live far away. And it's always a special moment when we display them on the fireplace mantel before Christmas. I also have a great time designing them or choosing photographs; it's a lot of fun.

let it snow...
let it snow...
let it snow...

WISHING YOU HAPPY HOLIDAYS FILLED WITH SPARKLES!

Jingle Bells

SUZANNE SYZ
2012

Y
*Year
(10th Anniversary)*

What does success mean for you? How would you like to see your company succeed?

Obviously success is important for any company to succeed and it's reassuring. For me personally it's a wonderful confirmation that people like what I'm creating, and that the path I've taken was the right one: to create only one-off pieces! Ten years ago this was an adventure, especially when everyone was producing for the mass market! My highest priority for the company is to always maintain the high standards of our workmanship and the originality of my designs with stones of the best quality. Even if we will grow further, the quality and exclusivity will always be the most important.

How do you see yourself today? Did you ever imagine that you would be where you are now?

I never expected my work to take me in so many different directions. For instance, I never expected to go to Asia and receive amazing television and magazine coverage. Ten years ago, I imagined a more traditional direction: old Europe, England, America…

Less global?

Yes.

Do you like this global aspect?

Yes, I love it! The world is flat thanks to the Internet. It's an amazing adventure for all of us! To see how tastes evolve from continent to continent is interesting and fascinating. People learn quickly and want to know more. It's amazing to see how many people are attracted by the idea of luxury, exclusivity, creativity, and Swiss savoir-faire. In a way, I'm reassured by the fact that others think like me, which motivates me to push the boundaries even further in my work.

And if you had to do it again?

In a minute!

ZYS
MADE IN

SYZ
SYZERLAND

Pièce Unique n°277: *Alice in Wonderland* ring.

Pièce Unique n°169: *Spider* earrings.

Pièce Unique n°314: *Girl's Best Friend* earrings.

From top: Pièce Unique n°15: *Mushroom* ring.
Pièce Unique n° 97: *Toadstool* brooch.

Pièce Unique n°358: *Skaramoosh* ring.

Pièce Unique n°283: *You 4 Me/Me 4 You* earrings.

Pièce Unique n°115: *Pink Spring* necklace.

Pièce Unique n°114: *Medici* earrings.

Pièce Unique n°11: *Prince Charming* ring.

Pièce Unique n°320: *Stargazer* ring.

Pièce Unique n°293: *Supercalifragilistic* earrings.

Pièce Unique n°306: *Touched by a Fairy* bracelet.

From left: Pièces Uniques n°260a, 260b, 260c: *Barbwire Loop* earrings.
Pièce Unique n°227: *Midnight Passion* earrings.

Pièce Unique n°295: *Once in a Blue Moon* earrings.

Pièce Unique n°237: *Queen Bee* earrings.

Pièce Unique n°357: *Rough* earrings.

Pièce Unique n°365: *Clochette's Green Nuggets* ring.

Pièce Unique n°59: *Lustres* earrings.

From left: Pièce Unique n°100: *Jingle Bells* earrings.
Pièce Unique n°313: *La Rose du Petit Prince* earrings.

Pièce Unique n°43: *Cherry* earrings.

Pièce Unique n°210: *Will o' the Wisps* earrings.

Pièce Unique n°247: *Smarties* ring.

Pièce Unique n°158: *Fallover Beethoven* ring.

From left: Pièce Unique n°103: *Galets* earrings.
Pièce Unique n°147: *Sea of Oz* ring.

From left: Pièce Unique n°3: *E.T.* necklace.
Pièce Unique n° 170: *Big Beryl* ring.

Pièce Unique n°81: *Feuillage* earrings.

Pièce Unique n°166: *Girouettes* earrings.

Pièce Unique n°271: *Kiss Me Love Me* earrings.

Pièce Unique n°203: *Life Savers* earrings.

From left: Pièce Unique n°93: *Chandelier* earring.
Pièce Unique n°305: *Smilies* shirt fronts.

Pièce Unique n°19: *That's a Question Mark* brooch.

Pièce Unique n°116: *Medici* brooch.

Pièce Unique n°117: *Painter's Palette* earrings.

Pièce Unique n°253: *Smarties All Over* necklace.

Pièce Unique n°165: *Lily of the Valley* earrings.

Pièce Unique n°243: *Royal Flush* earrings.

Pièce Unique n°160: *Life Savers* earrings.

From left: Pièce Unique n°269: *Smarties Hoops* earrings.
Pièce Unique n°190: *Smarties* earrings.

Pièce Unique n°353: *Empress's Garden* earrings.

From left: Pièce Unique n°334: *Dogs Love* bracelet.
Pièce Unique n°271: *Kiss Me Love Me* earrings.

From left: Pièce Unique n°175: *Autumn Oak Leaves* earrings.
Pièce Unique n°9: *Prince Charming* bracelet.

From left: Pièce Unique n°106: *Crab* brooch.
Pièce Unique n°23: *Amonite Flower* brooch.

Pièce Unique n°356: *Dragon of the Year* bracelet.

From left: Pièce Unique n°236: *La Fiorentina* ring.
Pièce Unique n°242: *True Blue* earrings.

From left: Pièce Unique n°284: *True Blue* ring.
Pièce Unique n°198: *Pigeon Blood* ring.

From left: Pièce Unique n°300: *Supercalifragilistic* ring.
Pièce Unique n°384: *Snow White* earrings.

From left: Pièce Unique n°216: *Columbian Tail* bracelet.
Pièce Unique n°241: *Symphony in Rock & Roll* ring.

From left: Pièce Unique n°157: *Aurora* earrings.
Pièce Unique n°250: *La Preziosa* ring.

Pièce Unique n°270: *Sissi* earrings.

From left: Pièce Unique n°294: *Color Me Baby* earrings.
Pièce Unique n°240: *Lucy in the Sky* ring.

Pièce Unique n°24: *Sea Urchin* necklace.

From left: Pièce Unique n°249: *Blue Lotus* ring.
Pièce Unique n°205: *Vita Bella* bracelet.

Pièce Unique n°372: *Summer Breath* earrings.

Pièce Unique n°81: *Autumn Leaves* necklace.

Pièce Unique n°33: *Flakes* brooch/pendant.

Clockwise from top left: Pièce Unique n°201: *Scarlet Fever* ring.
Pièce Unique n°66: *Midsummer's Night Dream* necklace.
Pièce Unique n°391: *Big Ben* earrings.

ACKNOWLEDGMENTS

Suzanne Syz would like to give a special thank-you to: Christopher Lopez-O'Ferrall at Suzanne Syz for coordinating this project; Nicolas Trembley, curator at the Syz Collection; and Irène Perlari and Ariuna Tsogoo at Suzanne Syz for making it all come true.

The publisher wishes to thank Barbara von Bismarck and the following individuals: Jennifer Belt at Art Resource; Gary Lee Boas; Burke Bryant; Rowena Chiu at Hauser & Wirth; Daniel Davis at Anthony Reynolds; Bridget Donahue at Gavin Brown's Enterprise; Frank Elbaz and Daphné Kossmann at Galérie Frank Elbaz; Jennifer Etkin at Simon Lee; Simon Greenberg at 303 Gallery; Stefanie Hessler; Janet Hicks at Artists Rights Society; Leigh Montville at Condé Nast; Vincent Romagny at Air de Paris; Kimberly Tishler Rosen at VAGA; Diego Sanchez and Sylvie Fleury; Mary Scholz at Getty Images; Ron Warren at Mary Boone; Laurie Platt Winfrey at Carousel Research.

SUPPLEMENTAL ART INFORMATION

Pages 126–127, from left: Guyton Walker, *Untitled*, 2009. Inkjet and silkscreen on canvas and drywalls and paint cans, 211.8 x 104.3 inches (538 x 265 cm). Courtesy of the artist/Air de Paris; Rosemarie Trockel, *Balaklava*, 1986. Wool and vitrine, 51.2 x 19.7 inches (130 x 50 cm.) Courtesy of the artist/Sprüth Magers; Elaine Sturtevant, *Warhol Flowers 8*, 1969–1970. Synthetic polymer and acrylic on canvas, 11.2 x 11.2 inches (28.5 x 28.5 cm). Courtesy of the artist/Anthony Reynolds Gallery; Jason Rhoades, *Biscuit* (*Idol 55*), 2005. Neon, glass, 28.3 x 10.2 x 10.2 inches (72 x 26 x 26 cm). Courtesy of Hauser & Wirth. *On table:* Thomas Schütte, *2 Ceramic Sketches* (*Woman*), 1999. Each 9.8 x 13 x 11.4 inches (25 x 33 x 20 cm). Courtesy of the artist/Marian Goodman Gallery. *Pages 128–129, from left:* John Armleder, *Furniture Sculpture n°143*, 1987. Acrylic on cotton, two tumbas, 118.1 x 78.7 inches (300 x 200 cm). Courtesy of the artist/Vera Munro; Rob Pruitt, *Cardboard Monster: Alison*, 2010. Baled cardboard, socks, shoes, refitted electric clocks, wood, Comme des Garçons Odeur 53.7 feet high (2.15 meters). Courtesy of the artist/Gavin Brown's Entreprise; Barbara Kruger, *Untitled* (*Man's Best Friend*), 1987. Photographic silkscreen on vinyl, 95 x 113 inches (242 x 287 cm). © Barbara Kruger. Courtesy of Mary Boone Gallery, New York/Sprüth Magers. *Page 131:* Jason Rhoades, *Chandelier* (*Baby Hole, Fun Hatch, Wonder Bread*), 2005. Neon, metal, 39.4 x 25.2 x 13.8 inches (100 x 64 x 35 cm). Courtesy of Hauser & Wirth. *Page 132, from left:* Mike Bidlo, *Not Warhol* (*One Yellow Marilyn, 1962*), 1984. Acrylic and silkscreen on canvas, 18.9 x 17.9 inches (48 x 45.5 cm). Courtesy of the artist/Bruno Bischofberger; André Arbus, *Grand Actéon*, 1940–50. Bronze, 63 inches (160 cm). Courtesy of Galerie du Passage, Paris. *Page 133, from left:* Thomas Ruff, *jpeg ny05*, 2004. 111.4 x 66.1 inches (283 x 168 cm). Courtesy of the artist; Richard Artschwager, *Table Prepared in the Presence of Enemies II*, 1992. Wood, metal, screws, and formica, 49.2 x 81.5 x 22.4 inches (125 x 207 x 57 cm). Courtesy of the artist/Sprüth Magers; Cindy Sherman, *Untitled 355*, 2000. C-print, 36 x 24 inches (91.4 x 61 cm). Courtesy of the artist/Sprüth Magers; Isa Genzken, *Memorial Tower* (*Ground Zero*), 2008. Plastic, tape, spraypaint, acrylic, mirror foil, film-strip, color print on paper, MDF, casters, 124.4 x 31.7 x 35.4 inches (316 x 80.5 x 90 cm). Courtesy of the artist/Hauser & Wirth. All works courtesy of the Eric and Suzanne Syz Collection.

PHOTO CREDITS

Pages 4–5: © Roe Ethridge/courtesy of Andrew Kreps Gallery; page 6: © Patrick Demarchelier; page 8: © Philippe Fragnière; page 11: courtesy of the artist/Galerie Andrea Caratsch. Photo: © Philippe Fragnière; page 12: © Denis Hayoun, Diode SA; page 13: courtesy of the artist/Sprüth Magers/303 Gallery; page 14: Photo: © Christopher Burke, © Louise Bourgeois Trust/Licensed by VAGA, New York, NY; page 15: © Philippe Fragnière; page 16: © Barbara Kruger; courtesy of Mary Boone Gallery, New York/Sprüth Magers; page 17: © Denis Hayoun, Diode SA; page 18: All images courtesy of Suzanne Syz. Photos: © Philippe Fragnière; page 20: Both images © Denis Hayoun, Diode SA; page 21: © Carsten Höller, 2012. Photo: © Philippe Fragnière; page 23: © 2012 Julian Schnabel/Artists Rights Society (ARS), New York. Photo: © Philippe Fragnière; pages 25, 26–27: © Philippe Fragnière; page 28: © Denis Hayoun, Diode SA; page 29: Lunic; page 30: © Philippe Fragnière; pages 31, 32: © Denis Hayoun, Diode SA; pages 33, 34: © Philippe Fragnière; artwork © Sylvie Fluery; pages 35, 37, 38: © Denis Hayoun, Diode SA; page 39: © Philippe Fragnière; page 40: © Martin Creed; page 41: © Katstudio; pages 42–43: courtesy of Peter Fischli/David Weiss/Sprüth Magers. Photo © Philippe Fragnière; pages 44, 45, 46: © Denis Hayoun, Diode SA; page 47: courtesy of the artist/Hard Hat/Galerie Frank Elbaz; page 49: © Philippe Fragnière; page 50: courtesy of the artist/Gavin Brown's Enterprise, New York/Balice Hertling; page 51: © Katstudio; pages 52, 53: © Philippe Fragnière; page 54: courtesy of Suzanne Syz; pages 55, 56: © Denis Hayoun, Diode SA; pages 57, 58–59: © Philippe Fragnière; page 60: Photo: © Arturo Zavala Haag for *Architectural Digest Spain*. Art © The Estate of Jean-Michel Basquiat/ADAGP, Paris/ARS, New York 2012; page 61: Photo: © Wolfgang Günzel; courtesy of the artist/Air de Paris, Paris. page 62: © Svetlana Kazakova; page 63: © Arturo Zavala Haag for *Architectural Digest Spain*; page 64: Photo: © Christopher Burke, © Louise Bourgeois Trust/Licensed by VAGA, New York, NY; page 65: © Denis Hayoun, Diode SA; page 66: courtesy of Suzanne Syz/© Svetlana Kazakova; pages 67, 68: © Denis Hayoun, Diode SA; page 69: © Philippe Fragnière; page 70: © Denis Hayoun, Diode SA; page 71: © Philippe Fragnière; page 72: © 2012 The Andy Warhol Foundation for the Visual Arts, Inc./Artists Rights Society (ARS), New York; page 73: © 2012 The Andy Warhol Foundation for the Visual Arts, Inc./Artists Rights Society (ARS), New York. Photo: © Philippe Fragnière; pages 74–75: All images courtesy of Suzanne Syz; page 76: © Denis Hayoun, Diode SA; page 77: © Philippe Fragnière; page 78, top: courtesy of Gary Lee Boas. Photo © Philippe Fragnière; page 78 bottom, 79: © Denis Hayoun, Diode SA; page 80: WireImage; page 81: © Denis Hayoun, Diode SA; page 82: Jerry L. Thompson/Art Resource, NY. Permission Estate of Edward Steichen; Steichen/*Vanity Fair*; © Condé Nast ; page 83: © Getty Images; page 84: © Denis Hayoun, Diode SA; page 85: © Philippe Fragnière; page 86: © 2012 The Andy Warhol Foundation for the Visual Arts, Inc./Artists Rights Society (ARS), New York. Photo: © Philippe Fragnière; page 87: © The Estate of Jean-Michel Basquiat/ADAGP, Paris/ARS, New York 2012. Photo: © Nicolas Syz; page 88: © George Condo, 2012. Photo: © Nicolas Syz; pages 89, 91, 92, 93: © Denis Hayoun, Diode SA; pages 95, 96: © Philippe Fragnière; Pages 97, 98: © Denis Hayoun, Diode SA; page 99: courtesy of the artist/Anthony Reynolds Gallery; page 100: © Katstudio; page 101: © Denis Hayoun, Diode SA; page 102: courtesy of Suzanne Syz; page 103: © Philippe Fragnière; page 105: © Denis Hayoun, Diode SA; page 106: courtesy of Suzanne Syz; page 107: © Philippe Fragnière; page 108: © Denis Hayoun, Diode SA; page 109: © Philippe Fragnière; page 110: All images © Denis Hayoun, Diode SA; pages 111, 112–113: © Philippe Fragnière; pages 114–115: © Lunic; page 116: courtesy of Suzanne Syz; page 117: © Katstudio; page 118: © Philippe Fragnière; page 119: © Denis Hayoun, Diode SA; pages 120–121: courtesy of Suzanne Syz; pages 122–123: © Philippe Fragnière; page 125: courtesy of Suzanne Syz; pages 126–127, 128–129, 131: © Philippe Fragnière; page 132: © Arturo Zavala for *Architectural Digest*; page 133: Thomas Ruff: © 2012 Artists Rights Society (ARS), New York/VG Bild-Kunst, Bonn; Richard Artschwager: © 2012 Richard Artschwager/Artists Rights Society (ARS), New York. Photo: © Philippe Fragnière; pages 134–135: © Philippe Fragnière; pages 136, 137: © Denis Hayoun, Diode SA; page 138: courtesy of Suzanne Syz/Arturo Zavala Haag for *Architectural Digest Spain*; page 139: © Denis Hayoun, Diode SA; pages 140–141, 143: © Philippe Fragnière; pages 144, 145, 146, 147, 148: © Denis Hayoun, Diode SA; page 149: © Philippe Fragnière; pages 150, 151: © Denis Hayoun, Diode SA; page 152: © Philippe Fragnière; page 153, 154, 156, 157: © Denis Hayoun, Diode SA; page 158: © Philippe Fragnière; page 161: courtesy of Suzanne Syz; pages 162–163: All images courtesy of Suzanne Syz except: pg. 163, left column, third from top: © Philippe Fragnière; bottom right: © Damien Meyer/AFP/Getty Images; pages 164–165: © Philippe Fragnière; pages 166, 167: © Denis Hayoun, Diode SA; page 169: © Ezra Petronio; page 171: © Louisa Gagliardi; page 172: © Philippe Fragnière; pages 174–175: © Lunic; pages 176–177: © Philippe Fragnière; pages 178–179: courtesy of Suzanne Syz/© Philippe Fragnière; pages 181, 182: © Philippe Fragnière; page 183: © Denis Hayoun, Diode SA; page 185: © Denis Hayoun, Diode SA; pages 186–187: © Svetlana Kazakova; pages 188, 189: © Philippe Fragnière; pages 190–191: courtesy of Suzanne Syz/© Lunic/© Philippe Fragnière; pages 192–193: © Philippe Fragnière; page 194, top: © Denis Hayoun, Diode SA; pages 194 bottom, 195: © Philippe Fragnière.

www.suzannesyz.com